THE **PERSONAL ORGANIZING** *Workbook*

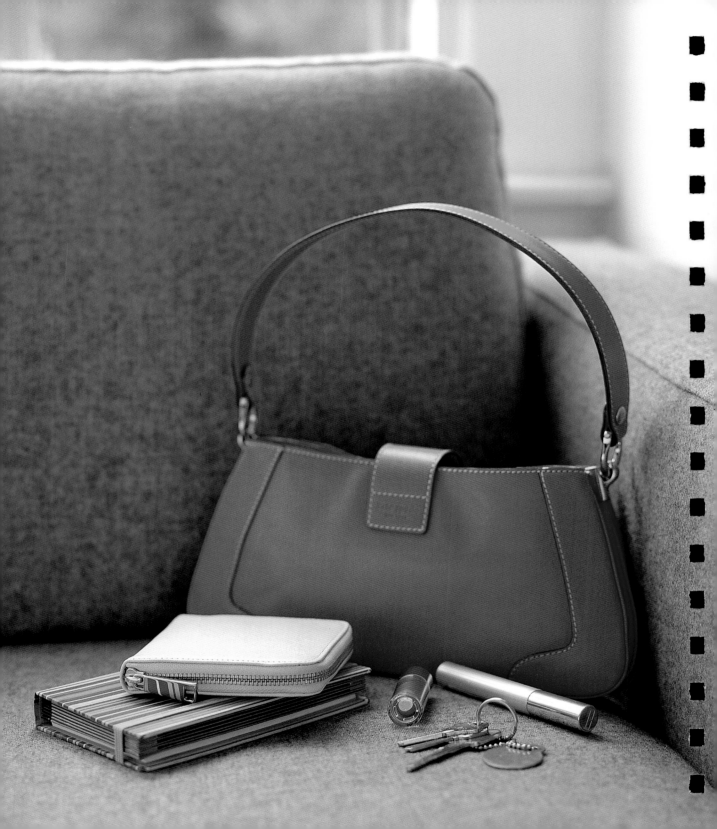

The Personal Organizing
Workbook

Solutions for a Simpler, Easier Life

By Meryl Starr

Photographs by Thayer Allyson Gowdy

CHRONICLE BOOKS
SAN FRANCISCO

Text copyright © 2007 by Meryl Starr.

Photographs copyright © 2007 by Thayer Allyson Gowdy.

Library of Congress Cataloging-in-Publication Data available.

ISBN-10: 0-8118-4942-2
ISBN-13: 978-0-8118-4942-5

Manufactured in China

Designed by Sara Schneider
Styling by Karen Schaupeter/Filly

Distributed in Canada by Raincoast Books
9050 Shaughnessy Street, Vancouver, British Columbia V6P 6E5

10 9 8 7 6 5 4 3 2 1

Chronicle Books LLC
85 Second Street, San Francisco, California 94105
www.chroniclebooks.com

This book is dedicated to all those who are ready to make a positive change in their lives.

Begin your journey; acknowledge the changes; honor the challenge.

* * *

CONTENTS

INTRODUCTION

What's the opposite of overwhelmed? Few of us could say for sure, because it's not a feeling we get to have often. Most of us spend all day, every day, in triage mode, helping solve a problem for a friend, sibling, or significant other before another problem pops up with our kids, parents, or neighbors. When we collapse in bed at the end of another exhausting day, we've somehow managed to take care of almost everybody . . . except ourselves. And the cycle starts all over again in the morning—no wonder so many of us lie awake nights!

Now hold that thought. Imagine for just a minute that tomorrow *can* be different.

- **Tomorrow you can know where everything is.**

- **You can conquer your to-do list with time to spare.**

- **You can quit worrying about problems and start solving them instead.**

- **You can spend more quality time with the people you care about most.**

- **You can handle the unexpected and stay relaxed and ready for whatever's next.**

- **You can find time for yourself and look forward to tomorrow.**

Feels good, doesn't it? There's a rush that comes with realizing your own power—it's that exhilaration you get when you win a promotion, or speak up at a PTA meeting, or stand tall in high heels. But nothing compares to the charge you can get out of really leading your life, instead of letting it lead you.

It's not just an instant zing, either: you'll find that you're calmer, happier, fulfilled, and, well, *whelmed* for a change. The people around you can't help but notice and feel inspired. If we could all accomplish what we're capable of and live our lives to the fullest, think of how different our families, our workplaces, our communities, even our world might be!

"Sounds great, but I'm just not that organized . . ."

As a personal organizer and coach, I've heard this from almost of all my clients at some point. But organization isn't a gene you're either born with or without. It's just a habit, and anyone—and I do mean anyone—can get into the habit. I've seen clients undergo tremendous personal losses, devastating divorces, unexpected career changes, and paralyzing depression, and emerge feeling better than ever about themselves because they've reclaimed their lives one room, one task, one problem at a time. When you take charge of your life, organization seems to come easily.

Organization replaces a vicious cycle of self-doubt and disappointment with a positive one of self-confidence and accomplishment. Step by step, *The Personal Organizing Workbook* will show you how to get that positive momentum going. Each chapter will take you to the next level of personal organization, focusing on your desires, your dreams, and your challenges. The more you accomplish in this book, the more you'll believe in yourself, and the more you believe in yourself, the more you'll accomplish.

Getting Started

Guess what? You're already on track to a simpler, easier, more organized life. Just picking up *The Personal Organizing Workbook* shows that you know your time is valuable, because you're willing to invest a few minutes reading this far to start using your time more profitably. Sure, you could tear through this entire book in a weekend, but I'd rather see you work your way through it one tip, one solution, one project at a time. That way, you'll get the hang of organization—you'll learn which tips work for you, what areas need the most attention in your life, and you'll develop a track record that proves that, actually, you *are* an organized person.

- You shouldn't have to run an obstacle course every day—**stash stuff out of your way,** so you can get done with tasks and get on with your life. We'll start small, organizing your wallet, your purse, your paperwork, even your closet. Soon you'll have everything you need at your finger-tips, without the frustration of fumbling around for it. Then we'll improve your work flow, so you can get through your tasks without them getting to you.

- Start making better use of your time by **making your to-do list doable.** The tricks here are prioritizing, consolidating, and using the most powerful word of all: *no.* Once you get the hang of carving out manageable tasks and sharing the responsi-bilities, you'll finally enjoy some long-overdue personal time.

- Redirect your attention toward the most important people in your life by **managing your relationships.** This means examining your people priorities, setting clear bound-aries and time limits, and learning to bow out gracefully when necessary. And you know those friends you never get to see? Now you'll have time to schedule that standing date you always talk about and host a no-stress get-together . . . party at your place!

- Get on track and **stay organized** with pos-itive habits that allow you to finish what you've started, and accomplish more than you ever imagined. You'll learn to replace old habits with new and improved ones, prevent pileup, delegate effectively, and be more realistic about your time. If you want to grow as a person, a parent, a friend, a professional, you name it, you need to give yourself time—and once you're organized, you'll have all the time you need. So go ahead: take your dreams seriously enough to put them on your calendar . . . in ink!

Head Start to Happiness

The Personal Organizing Workbook asks you to ask yourself, "What makes me happy?"—and to start living the answer. Maybe you've been so worried about getting through the mechanics of living that you haven't really thought about it lately. In the rush of our lives, we can forget who we are, where we've come from, and what we set out to achieve. Sometimes desires and goals change, but we never seem to find the time to realign our actions to achieve those new goals. It's hard to look up over those piles of papers, past our crowded closets and between appointments in our busy schedules—but it's crucial to realizing the fulfillment and serenity you can achieve in your everyday life.

Getting organized may seem intimidating at first—but *The Personal Organizing Workbook* is here to make it easy for you. As you work through one problem and project at a time, you'll see for yourself how small efforts can bring tremendous rewards. Organization isn't about big, daunting tasks, like color coding your DVDs or labeling all your kitchen shelves—it's about knowing and accepting yourself, and taking control of your life instead of letting the things in it control you. We've all wasted entirely too much time beating ourselves up because we're running late, or we can't find something we're looking for. Finally, you can let go of all that unnecessary frustration and live a little. My goal is for you to achieve success, to feel fulfillment and serenity in your everyday life, to feel good about who you are . . . today and always.

Fact is, you're already on your way. By taking the small steps outlined in *The Personal Organizing Workbook,* you're starting a process that will guide you toward success, self-love, and your greatest personal fulfillment. Never again will you hear yourself say those dreaded words: "If I only had the time, I'd . . ." Once you start to get organized, you'll have time to spare. Life doesn't have to be so hard. Instead of stressing out about feeling overwhelmed and out of control, you can start doing things that make you feel good. So come on—**let's get organized!**

stash your **STUFF**

We all love stuff. We get a kick out of buying it, displaying it, putting it to good use, and receiving it for our birthdays. But sometimes instead of owning our stuff, our stuff starts owning us. Stuff just can't seem to stay where it belongs: toys end up in driveways, favorite clothes wind up at the bottom of piles on the floor, flashlights are never anywhere to be found during black-outs. On the other hand, we can always find the things we don't want or need: junk mail, chipped china, wads of chewed gum, a hundred thousand loose paper clips.

We need to show our stuff who's in charge here, and that's what this chapter is all about. It pinpoints the pernicious stuff that tends to pile up, get in the way, and bonk us on the kneecaps—and explains how you can clear a path right through all that clutter. You'll lighten your load, and become happier, healthier, and safer in the bargain. Sorting through your stuff can help you do right by the planet and some worthy charities, and it can mean good fun with friends, too. Shedding some stuff can even make you richer, and you'll find out exactly how right here.

By the time you reach the end of this chapter, you'll have conquered the Mount Everests of stuff in your home and car; discovered what all that stuff in your wallet, purse, and mailbox actually is; and made room in your life for inspiration and success. Isn't it time to stop stressing about your stuff, and start enjoying it instead? You've got the stuff . . . now stash it!

questionnaire

* * *

1 : **Are there any areas of your home you tend to avoid?**

If you're nodding and rolling your eyes, the place you have in mind is probably the most cluttered area of your home. This is a great place to begin! Go directly to page 25, and start reclaiming your personal space.

2 : **How often do you find yourself having to warn guests in your home or car not to bump into things?**

More than once is probably too many times—just think of the potential for stubbed toes and broken prized possessions, not to mention the liability issues. Turn to page 26 for hints on stowing your stuff in safe places.

3 : **How often do you look around the backseat of your car and wonder, "What is all this stuff?"**

Unless we're talking about a surprise birthday party filled with balloons and flowers, this shouldn't be happening to you. The whole point of personal space is that you choose what belongs in it. Start making room for the things that you really want to bring with you using the exercise on page 42.

The Personal Organizing Workbook

4 : **If you had to give instructions to a family member, friend, or neighbor where to find a commonly used item in your home, would your explanation be short or long?**

If you'd have to launch into a long explanation, you need easier access to key household items. Sort out your odds and ends and keep your tools handy with the guide on page 31.

5 : **Do you often find yourself fumbling around in your purse, trying to find your keys, wallet, change, gum, or some gadget?**

If this happens daily and takes more than a second, go to page 33 and get to the bottom of your purse pandemonium. That momentary panic when you think you've lost your wallet or cell phone is an experience not to be repeated, and fumbling for keys in a parking lot is downright dangerous. Groping for gum or change is risky when you're driving, too.

6 : **Is your shoulder ever sore at the end of the day from lugging around a heavy purse?**

If you can tote your bag all day without getting those telltale red marks on your shoulder, no problem. Otherwise, go to page 34 for hints on lightening that load. Hauling a heavy bag isn't just about a sore shoulder—it could do some serious damage to your muscles and your posture long-term.

7 : **Could you describe everything that's in your wallet without looking?**

There's no room in your wallet for mysteries—that's what makes it hard to find receipts, credit cards, checks, tickets, cash, and IDs. If you'd just as soon skip that panicky "It's in here somewhere . . ." moment at the check-out counter, skip to page 34 for tips.

8 : **Are any of your shelves buckling under the weight of the objects on them?**

If so, don't wait for them to come crashing down. Lighten your load using the guidelines on page 38.

9 : **Are there certain closet doors or drawers you can't quite close? What about the glove compartment of your car?**

If you notice an overstuffed storage compartment, clutter is probably the culprit. Begin shrinking your stuff to fit the space available with the tips on page 39.

10 : **Are you running out of room for your family's prized collections of teacups, books, hats, baseball cards, antique toys, purses, etchings, sports trophies, etc.?**

The key word here is *prized*. Page 39 will show you how to prioritize your stuff so that favorite items are in plain view, keepers are stored for posterity, and the rest either finds a worthy home or earns you some cash.

11 : **How many boxes of miscellaneous keepsakes are there in your attic, basement, closets, and other storage spaces?**

More than one or two boxes of assorted keepsakes per space? Renting a storage space? Then flip to page 40 for storage tips that will save you time, space, and money.

12 : **Is it actually hard to squeeze five people into your five-seat car?**

Make more room for people and less room for mess in your car with the exercise on page 42.

13 : **Do you ever lose track of important documents, letters, tickets, or articles you wanted to read under piles of old bills, junk mail, and outdated magazines?**

Sound familiar? Clear up your paper trail using the tips on page 48.

Common Problems—and Solutions

Lots of people call themselves "pack rats" and feel bad about "hanging on to stuff"—but having stuff isn't necessarily a problem. It only becomes a problem when it's not organized, so that you forget what you have and are no longer enjoying it. The following ideas will help you cut through the clutter in your life, whether it's overflowing your wallet or making a mess of your living room. As your stuff gets sorted and stashed, don't be surprised if you locate a long-lost gift certificate or that remote control you'd given up on ever finding again. Once you're organized, your stuff will once again be at your service.

I'm overwhelmed. Where do I even begin?

Take a walk around your home or office. Are there any areas you dread entering, or even seeing? When you walk into a room or open a closet door and you can feel your energy just drop, that's your signal that you've found a perfect place to begin. Enter this problem area, close your eyes, and imagine what that space would look like with nothing at all in it. Just thinking about that empty space, you may notice your spirits beginning to lift already. Next, ask yourself: if you lost all that stuff, what would you really miss? Make a mental list . . . no peeking!

Now open your eyes, and take a look around. How many items in the room didn't make the cut? What did you forget about completely—piles of old magazines, six remote controls, those porcelain shepherdesses you inherited from Aunt Frieda, endless end tables? Are these items making it hard for you to get to or even see a favorite vase, important documents, your computer, or other things that made it onto your mental list? Are they making it hard to move freely around the room? You could probably live without a lot of these forgettable items, and make life a whole lot easier on yourself in the process. To get started, try out the solutions on the next page.

tip

Who's in control? You are!

If your remote controls seem to be multiplying, you can get the situation under control by investing in a single universal remote that can control your television, DVD player, stereo, the works. If you still have separate remote controls for video games, TiVo, and the like, make sure they're stowed with the appropriate device when not in use. That way, you'll never have to search frantically under couch cushions when all you want to do is relax, already.

Organizing Solutions:

Look for the ouch factor. Every parent knows about childproofing—covering electrical outlets and adding latches to cabinets containing household chemicals—but what about *adultproofing*? Try these tips to make your house safe for grown-ups:

- Check high-traffic areas like hallways and stairs, and notice any piles that might make you stumble and fall when you're sleepy or in a rush.

- The sharp edges of coffee tables, chairs, and end tables should never come between you and the door. Furniture needs to be rearranged or removed if it ever barks your shins, or leaves you black-and-blue.

- Before you have a dinner party, look around the area where you'll be entertaining and the sidewalk in front of your house to be sure the coast is clear. You don't want a guest who's had one too many to slip on that toy tractor.

Reclaim your personal space. Go through your living area, and remove items that fall into one of these categories:

- *Someone gave this to me, and I feel guilty about getting rid of it.* Don't feel guilty! It was the thought that counted, after all. Besides, that person probably won't even notice it's not on display.

- *I'm keeping this for someone else.* Give it to that person now, or put it away for safekeeping. Your living room is not a storage unit.

- *This is something I borrowed from someone else.* Return it this week—it'll be such a relief for everyone.

- *I'm keeping this for my records.* Shelve it with the rest of your records, out of sight and out of mind.

- *Another person in my household left this item here.* Return it to that person, or leave it in an in-box or on a chair. This is a gentle but firm hint that others need to clean up after themselves.

Remove obstacles to success. You have a job to do in your home and car, whether that's caretaking, cooking, carpooling, or running errands. So take a good look at your work area, and ask yourself: What is getting in the way of your doing your job well? Is that stack of junk mail hiding bills you need to pay? Are the dog's squeak toys rolling around underfoot in the car? Is a pile of dishes making you think about ordering pizza for the third time this week instead of fixing a healthful meal? Put out-of-place objects where they belong, and you'll improve your working conditions.

Make way for inspiration. Are there so many tchotchkes on the mantle you can barely see your favorite photograph of your mom? Why is that award you're so proud of winning tucked away in the TV cabinet? Is the book that changed your life back in college hiding in some box somewhere? Clear away the stuff that doesn't matter so much to you so that you can give place of pride to your true inspiration. Even if you have to do some heavy lifting to make space for your prized possession, that little lift you get every time you notice it will make it all worthwhile.

The Personal Organizing Workbook

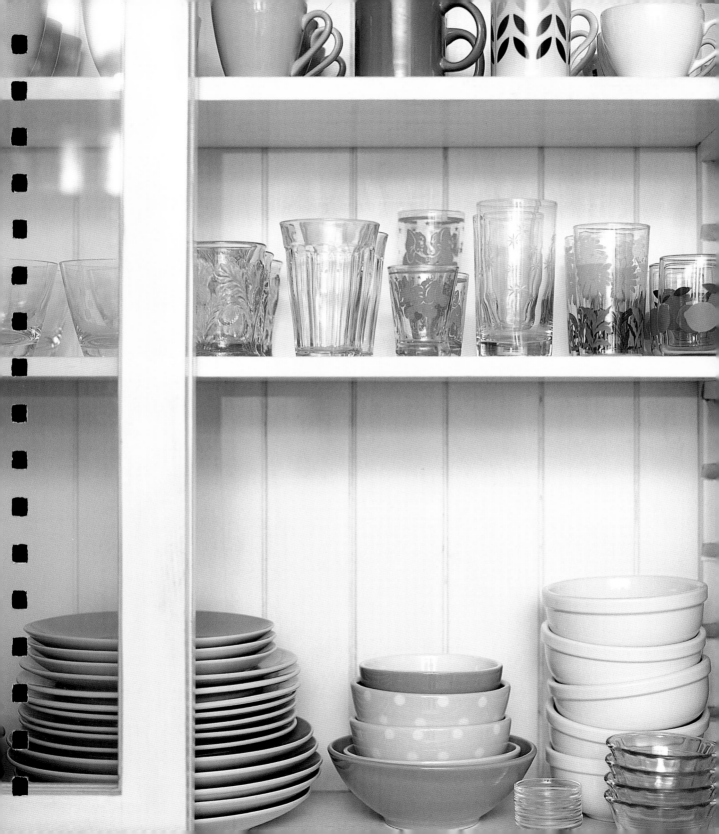

I can never find the things I need.

All right, let's have a show of hands: Who hasn't tried to use a stapler to bang a nail into the wall because the hammer was MIA? Or torn tape with your teeth when scissors were nowhere to be found? Or accidentally thrown out an RSVP card for a wedding, or a bill, or some other important piece of mail because it was buried in a pile of junk mail? Or realized (hopefully before anyone else does) that the mortgage document you've been frantically searching for is that paper you used as a coaster for your coffee mug, with all the splashes and circular stains on it?

If you've been there and done that, you're not alone. The tools and papers we use the most are also the most likely to be misplaced. Most tools are kept in miscellaneous junk drawers or crowded workbenches, and important documents can get lost in stacks of mail and magazines. We all forget to put things away, but sometimes we make it a conscious choice: since we might need that item again, what's the point of putting it away?

This is the logic that leads to clutter. One client of mine kept newspapers to read at a later date—and that ended up being three years. If you're done with a tool or document "for now," you probably won't need it again until later—at which point you may forget where you put it, or it could be under a pile of other items used more recently. So instead of keeping tools or papers "handy" on a crowded work surface, take a second to put them in their rightful place: a file of current bills, a toolbox, a sewing basket. That way, when you need an item again, you'll always know where to find it. Glasses, wallets, cell phones, and other key items should have permanent homes, whether that's in a dish in the front hall, in your purse, or in the charger. For ideas on where to put what, check out the suggestions on page 31.

Do the junk shuffle.

tip

Junk drawers can be useful spots to store potentially useful odds and ends, as long as the items in them might conceivably come in handy in that area of your home or office. For example, a bungee cord is not something most people need in a linen closet—but you might want to put it in the garage, where you'll actually use it to lash your surfboard to your car. Paper clips might not be so useful in a workbench drawer, so offload them to the study, where you need them. Scissors are useful in almost any room and so are pens. That said, anything that's broken, mangled, or covered in gum has out-lived its usefulness, and belongs in the ultimate junk drawer: the city dump.

Cut back junk mail.

tip

Request removal from direct-mail mass-distribution lists (see page 163 for Internet resources).

Every time you subscribe to a magazine, make a donation to a nonprofit, or give any business your contact information, add this sentence to your agreement: "Do not rent, sell, or exchange my name and address with anyone else."

Thin the herd.

tip

How many rubber spatulas do you really need in your kitchen, and what's that stray one doing in the bathroom? Wait, we don't want to know—let's just say that one should be the first to go. Nails are good to have on hand but not so many that they they're overflowing your toolbox or poke you every time you open a junk drawer. Expired canned goods and spices more than a year old have got to go, and you might consider donating extra barware and silverware that's taking up space in your kitchen cabinets. And about those rags: keep one with the shoe-polishing kit, a few by the workbench, and maybe one or two for dust cloths with your cleaning supplies. The other dozen need to be tossed. Call your waste disposal company for advice on disposing of any rag soaked in turpentine or other toxic chemicals.

Keep commonly used items in common areas. Files frequently referenced by you and your household should go in one centrally located file drawer or cabinet, not in the desk in your study (unless you enjoy all those interruptions). Think about what others ask to borrow from you most often, and keep those items in a readily accessible, logical place: keep nail clippers on the bottom shelf of the medicine cabinet in the bathroom, a stapler on the desk in the den, car keys in the hallway. If your teenager uses the family car often, make sure the keys are hung back on a hook in the hallway—or car privileges will be lost.

Stop collecting fossils. Humankind has been using tools ever since the Stone Age—and sometimes it seems as if we've been collecting them just as long. Do you really need that Late Jurassic computer in the attic, when you have last year's model? Same goes for that Sony Walkman circa 1982 and all the cassette tapes that you never listen to anymore—if you own it on CD, ditch the tape. You've hung on to the riding mower with the blown gasket thinking that you'll fix it, but meanwhile it's just taking up space in your garage, like a wooly mammoth in a tar pit. If your outdated technology still works, call a school or nonprofit and see if they accept donations. You'll feel good, and you may even get a tax write-off out of it. If you have a truly classic piece of technology—a 1960s bubble TV, a functioning 1940s radio, the first Macintosh computer—consider donating it to a local technology or history museum or selling it

on eBay. Call a waste management company to dispose of outdated technology properly, since the components can be toxic.

Sweep up your paper trail. If it's paper, it belongs one of five places:

- *In a centrally located desk or cabinet.* Apartment leases, manuals for computers and other appliances, phone books, bills, and other key household documents belong in a desk or cabinet in the den or kitchen—someplace where someone with a crashed computer can get to it in a hurry, without having to ask anyone.

- *In a magazine rack.* Make a pact that the magazine rack gets cleaned out the first of every month, so it doesn't become a dumping ground.

- *In the bedroom of its rightful owner.* From there, the owner can sort out whether it belongs in a desk drawer or recycling bin. Hint to parents of teenagers: this policy gives kids an incentive to clean up after themselves around the house, so that parents aren't constantly barging into their room with piles of stuff. Clever, huh?

- *On a central bulletin board next to the household calendar.* This is a good place to tack up tickets, invitations, and household shopping lists. Make sure it's cleaned off once a week, at least, so it doesn't become papered over with flyers and outdated postings.

- *In the recycling bin.* Make a decision about mail the day it comes in. If it doesn't belong in any of the above places, it gets recycled.

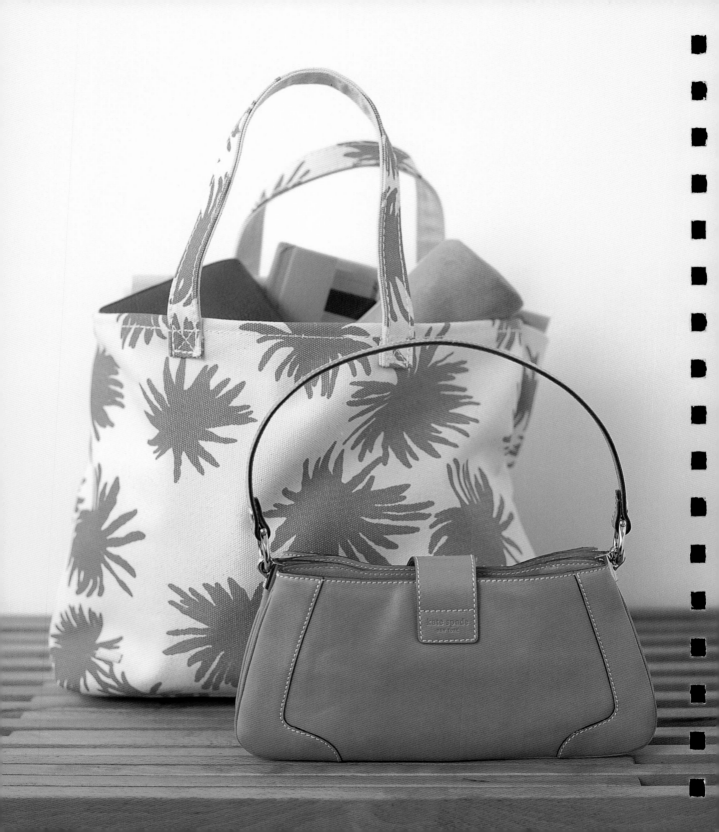

I'm always lugging around a heavy bag.

This can be a real pain in the neck, in more ways than one. Carrying too much baggage can wreak havoc with your health and your posture. Add up the potential medical expenses associated with those aches, pains, stumbles, and muscle strains, and you're basically volunteering to help your chiropractor, orthopedist, and acupuncturist put their kids through college. True story: a graduate student actually got a hernia from lugging around a backpack full of library books she kept forgetting to return! Travel light every day, and your body will thank you.

Personal safety is another key consideration. No woman's purse should be so stuffed that it's hard to find her keys at night, or she's left groping for her cell phone in the street. In the worst-case scenario, we all need to be able to run when we feel threatened—not easy to do when lugging a fifteen-pound bag. Consider also the signals you're sending with the hunched, slumped body language of a person loaded down with a heavy bag. Self-defense instructors recommend that for safety's sake, we should project calm, alert self-assurance when we're on the street. This is especially true when you're carrying a lot of cash or are in an unfamiliar part of town.

When you're out and about, you've got better things to do than wonder whether you've lost your wallet or left your Palm Pilot at home . . . not to mention that lost ID or winning lottery ticket that's supposed to be in your wallet! Don't panic; the solutions on the following pages will help lighten your load, and keep everything you need close at hand.

Organizing Solutions:

Scale down. Getting a smaller purse will force you to bring less with you. Look for ones with special compartments for your cell phone, loops for your keys, and pockets for gum. Bonus: smaller is cuter!

Use your pockets. Treat yourself to a night on the town, and bring only what you can fit in your pockets. See how little you actually need? You might be able to get away with only your driver's license, a little cash, and a credit card. If you're tempted to tote more, ask yourself: Who do you urgently need to talk to on your cell phone between acts at the opera? Do you really need to reapply lipstick during a movie you're watching with friends? The next time you go out, be just as ruthless with the stuff you're carrying in your purse. If you won't need it in the next few hours, it stays home.

Get a grip on gadgetry. Do you really need to bring your MP3 player along on a five-minute walk to the café? What about your cell phone? If you decide you really do need them, you might want to carry them in an easily accessible pocket instead of the bottom of your purse . . . hey, I'm just saying!

Cut back on cosmetics. The more you have in your purse, the more fumbling around in your purse you'll have to do all day. Apply your makeup at home, then toss in your purse only the two items most likely to rub off: mascara and lipstick. Word to the wise: put makeup in a special zipped compartment so that it doesn't make a mess if it opens in your purse.

Clean out your wallet. What's that thing that's weighing down your purse? Could it be a shot for shot-putting or maybe a set of horseshoes? Well, look at that . . . it's your wallet! When it's stuffed to overflowing, your wallet easily outweighs your cell phone, personal organizer, and schedule as the heaviest item in your purse. Dump out everything that's in your wallet, and sort out:

- *Your receipts.* Clean receipts out of your wallet at the end of every day, and put them in your to-do file. Then, when you have a moment, you can sort out what receipts you need to set aside to return an item on errand day, which ones you need to file for tax purposes, and which ones you can shred and recycle. (See page 50 for more on handling receipts.)

- *ATM receipts.* Put these in your weekly accounting file. Once you've entered those deposits and withdrawals into your ledger or accounting software program and double-checked them against your monthly bank statement, you can shred and recycle those ATM receipts.

Store credits and gift certificates. If you might use these over the weekend or on errand day, clip these to your to-do list or pop them in an envelope marked with the "do date." (See chapter 2 for more advice on creating a to-do list.)

Credit cards. Unless you're planning to buy the entire contents of a shopping mall, one major credit card and a check card should be plenty to cover your expenses on any given day. Store credit cards should be put away until you're planning to be in the part of town where that store is located.

Membership cards. Not going to the library, museum, or gym today? Then put these cards in a separate wallet in the car or in an easily accessible desk drawer until you do need them. If returning books is on your errand-day to-do list, then clip your library card to your to-do list, or pop it in an envelope marked with the "do date."

Checkbook. Use your check card or credit card for purchases so you can leave your checkbook at home in your desk, where it will come in handy to pay bills as you do your accounting. In case a store doesn't accept check cards, keep just one check in your wallet (note the check number in your check register).

Pictures. Don't confuse your wallet with a brag book! Choose no more than three of your very favorite wallet-size photos to include in your wallet. Instead of including a photo of your significant other, children, parents, siblings, and best friends, have a group photo taken—or drag your loved ones down to the mall and get some of those fun, tiny sticker snapshots taken at a sticker photo booth. You can fit several of these in your wallet without weighing it down.

Money. Empty most of your change into a piggy bank each night, and you'll lighten your load for the next morning. (This has got to be the world's easiest way to start a savings account, too!) Commuters, leave your change in the front-seat coin holder so that you'll never need to worry about finding change for tolls again.

Tickets. Tack up movie tickets, dry-cleaning receipts, and tickets to the theater or sports events in plain sight on the household bulletin board, right next to the household calendar listing the big event.

Stick to the basics.

There are just seven basics for a well-organized purse:

1. A wallet with a current photo ID, some cash, and a credit card in it

2. A pocket calendar or electronic organizer with your day's schedule and phone numbers for any appointments

3. A notebook or tape recorder for jotting down ideas or reminders as they arise

4. A pen

5. A comb

6. A tissue or two (bless you!)

7. A special pocket for easy access to keys

Think small!

Once you stop toting your checkbook around, you can downsize from an unwieldy folio-size wallet to a smaller, cuter one.

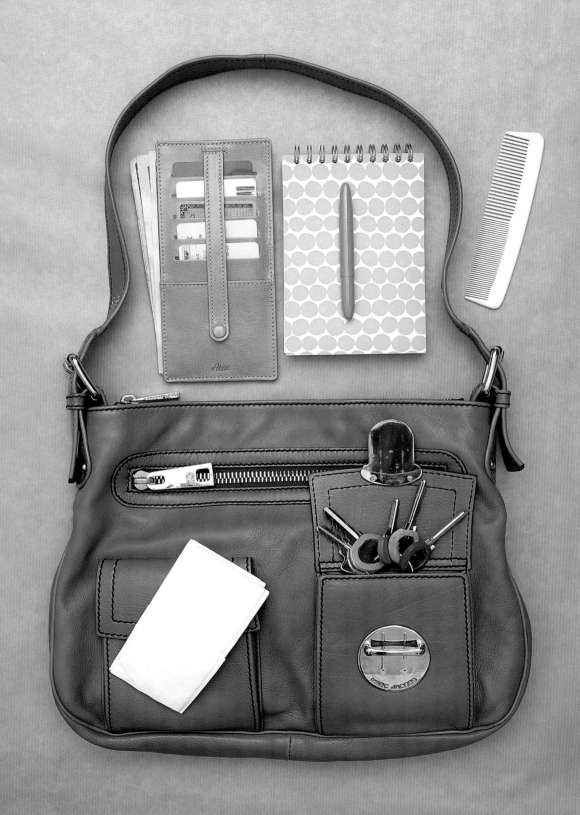

Problem:

I'm running out of storage space.

So the first thing to do is head to the store and invest in more boxes, cabinets, shelves, and other storage systems, right? Not exactly. If your shelves and cabinets are full, adding more storage without getting rid of some of the items creating the problem will only encourage you to accumulate even more stuff. A book lover I know "solved" her problem of towering stacks of books by buying taller bookshelves, which eventually collapsed under the weight of her burgeoning book collection. Sooner or later, we all have to deal with the real problem at hand: it's stuff, not storage.

How do you begin shrinking your stuff to suit the space available? Start with the obvious: overflowing drawers and buckling shelves that are unsightly and unstable. You might be able to put some of the overflow into cabinets so that it's out of sight—but you want to have it out of mind, too. Before you put it into storage, ask yourself whether this item is truly something you will use again, or if it is a keepsake a family member will treasure. If it is, box it up and mark the box accordingly: "Holiday ornaments" and "Andrew's baby pictures" are useful categories; "Miscellaneous," not so much.

You may find that to fit a box of treasures in your storage compartment, you need to clear out a couple of boxes that fall into that miscellaneous category. Someone's got to sort through all that memorabilia sometime—and if it's hard work for you to do it now, just think of how much tougher it would be for your children and grandchildren to sift through all this stuff years from now. Spare them the trouble; there's no time like the present to make sense of the past. To get started, check out the solutions on the next page.

Organizing Solutions:

No more pushing and shoving. If a door or drawer won't close, don't force it. Open it up and see what's in the way—you may be surprised what you find in there. You may be reluctant to part with some long-lost treasure you discover, but consider this: if you never realized it was missing until now, you probably won't miss it when it's gone. For each item you take out, ask yourself these questions and take action accordingly.

- Do you need this item? Put it in a place where it will be most useful.
- Do you enjoy this item? Display it.
- Is it something you can give away to someone else who might enjoy it? Do it.
- Is it something you could sell as is or get restored and then sell? Cash in.
- Is it beyond repair, moldy, or a little smelly? Toss it.
- Could you do a good deed for the planet and recycle it?

Collect your collectibles. Collections of CDs, dolls, tools, and teacups have a way of expanding to fit the space available—and then some. They end up crowding shelves and spreading out into other rooms, storage spaces, and even offices. (One accountant was frustrated that her colleagues seemed to be taking her financial advice less seriously until a coworker gently pointed out that the toys in her office might be part of the problem.) Assemble all your collection in one room, and take a good look through it. Which are your favorites?

Display these prominently, leaving plenty of space around each so it can be admired properly. If there are any duplicates in your collection or items in perfect condition you can bear to part with, these would be wonderful heirlooms to give to a family member or friend. Otherwise, they could fetch a nice price at a resale shop. Are there any items that need to be fixed or restored? Put these to the side to be taken to a professional restorer for an estimate so that the item has the best chance of retaining its value. If you don't want to invest in restoration, consider selling it at a consignment shop, a yard sale, or on eBay, as is. You may be surprised at the price you'll get for it.

Clear your cache. If you love it, and it makes you feel good, and you have room for it, by all means keep it. But sometimes we collect things without even meaning to. We all know how it works: there's a sale on scarves so you buy three in different colors, your friends see you wearing them and buy you four more for your birthday, and before you know it you begin to understand how Imelda Marcos wound up with so many shoes. Most people have a similar stash, such as dried-up pens that overflow that mug on the desk and fill entire desk drawers. When you're keeping things you don't use or love, it's time to clear that cache. Clear out inkless pens, expired medicines, and scarves you never wear, and announce to others that you do not need any more pens, aspirin, or scarves until you've used the ones you already have.

Add and subtract.

If you're having a storage crisis, those ads offering storage "starting at only $24.99 per month" sound like a bargain. Don't believe it. Spend a rainy afternoon strolling down memory lane as you sort through the memorabilia in your attic or crawl space, and you could clear out storage space that'll save you $300 to $1,200 a year in storage-rental-unit costs. That's money you could use to treat yourself to massages or a much-deserved vacation or put toward the kids' college fund. And, as the experts on *Antiques Roadshow* always say, you never know what long-lost treasures you'll find in the attic!

Good riddance—and good money, too.

Here's how to make quick cash from castoffs at a tag sale:

• Price to sell. Everyone loves a bargain—so if you let every item go for the price of a latte, people won't think twice about loading up.

• Group items by price. That way, you won't have to label anything, and the bargain pricing will attract customers. Trust me, the penny table will clear itself!

• Offer discounts—early bird, end of day, buy one and get one free, seniors, students, starving artists, you name it. Good deals make happy customers—and repeat sales, too.

• Don't be too attached. Any money you make is a bonus, because you were getting rid of this stuff anyway. Just think of how much you'd have to pay to have all this stuff hauled away . . .

• Invite your friends to participate. You'll each get moral support when you go through your closets, help make signs and attract customers, and hang out together on a Saturday afternoon. If you swap a few treasures and actually make some sales, even better!

Clear Out the Car

Time required: 1 hour

Whether you're commuting or chauffeuring the kids to school, one of the first things you probably do every day is get in your car. When you do, you don't want to sit on grungy squeak toys, stale caramel corn, or a brand-new CD (ouch!). Clutter in the car isn't just an eyesore—it's a distraction that can keep you from noticing oncoming traffic. You know that wiggle-and-grope dance you do, trying to wrest a stray item out from underneath your rear at a stoplight? Once you've done this project, you can save those moves for the dance floor and focus on your driving instead.

1 **Set aside a time and date** when you will be free from interruptions. Set yourself up for success with a project, so you can look forward to that feeling of a job well done.

2 **Start with the driver's seat.** This is the most important area to keep clean and organized, so that nothing is rolling around underfoot and you're not groping around for a CD in the car door pocket when you should be concentrating on the road. Make sure that the only things that are here are things that absolutely, positively need to be within reach, such as change for tolls. CDs should be in the CD player before you leave your parking space, your cell phone should be on speaker (or turned off and tucked in your purse), and coffee should be in the holder, where it won't spill on you. Keep a couple empty plastic bags stashed away for garbage in the center armrest cache or side pocket.

3 **Next, clear the copilot's seat.** Maps belong in the side pocket on the passenger side of the car, so that the copilot can give directions to the driver. The glove compartment should contain the driver's registration. A CD case can be stowed in the front here, and the copilot should be in charge of changing the music and putting away CDs. Snacks should be kept up front, too, so that the copilot doesn't have to reach into the back for a quick bite while the car's in motion.

4 **Clear the back seat,** including the pockets on the backs of the front seat. This is where old snacks come to expire, stray documents turn up, and lost toys are found. If there's a baby on board, make sure a favorite toy is within reach or attached to the car seat. A couple of toys and kids' books are plenty; the rest should be taken out of the car and returned to the toy box. (Kids usually bring a couple with them to the car, anyway.) Remove anything from the ledge behind the windshield—all it takes is one sudden stop to send those objects flying, and bonk a passenger on the head.

5 **Don't forget the junk in your trunk.** Take everything out, and then put only the essentials back. Make sure you have a spare tire and your emergency roadside assistance kit: first-aid supplies, flares, a tire jack, a bottle of water, a flashlight with batteries, a gas funnel, and jumper cables. You might also add a cooler to keep items from the supermarket cool. Everything else you find in the trunk is just putting wear on the tires and lowering your gas mileage.

6 **Make it shine.** Pay the neighbor's kids to vacuum and wash your car, or go get it done professionally. Meanwhile, treat yourself to a coffee or a manicure—you've earned it!

Travel smart.

Keep a to-do list on the back of the sun visor in the front seat, so you can tell at a glance where you need to head next.

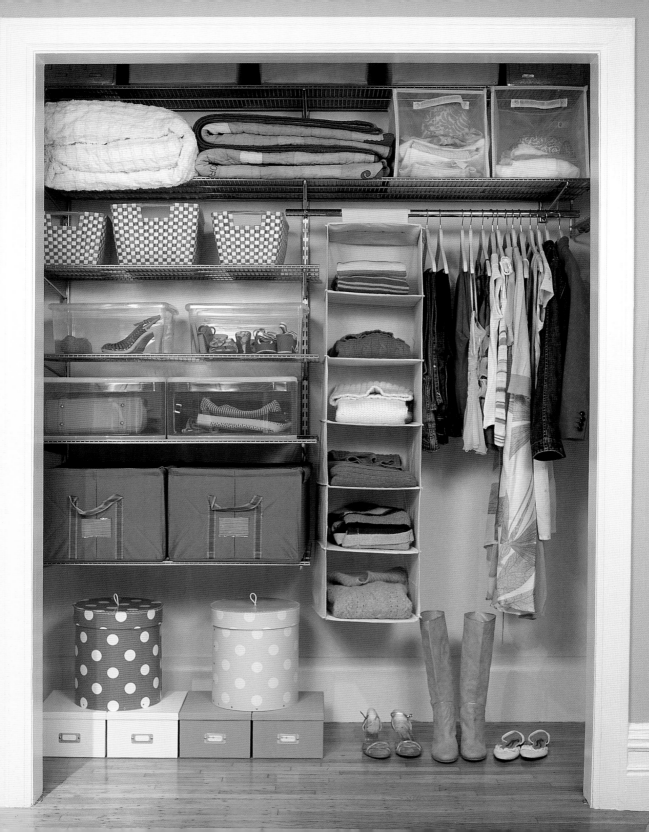

Sort Out Your Clothes Closet

Time required: 2 hours

Standing in front of a chaotic closet in the morning, you're faced with a critical decision: are you going to be on time or in style? You know how much time it could take to rummage through the racks and stacks and locate your favorite shirt, a warm-enough sweater, or that pair of shoes that would go perfectly with your outfit . . . do you risk it? Once you get that closet in order, never again will you have to deal with such a dilemma before you've even had your coffee. And on top of that, you'll make a nice donation to a worthy charity, thrill a friend or two with some cool castoffs, and maybe even score some cash from consignment. What's not to like about your closet now?

1 **Get some boxes,** and drag them near your closet.

2 **Rock that closet.** Crank up your favorite music, empty everything completely off the racks in your closet, and throw it all on the bed where you can see it. (If you share a closet with another person, just do this for your side, or your closet mate may be truly miffed!) You'll probably find items that you forget you had, and you may find yourself muttering things like "I've been looking for this . . ." and "Wow, that's where I put this?!" Good thing you have your music on, right?

3 **Divide your clothes into categories:** shirts, pants, dresses, etc. Do this so you can see how much of each item you have.

4 **Now pick out your favorites in each category**—things you wear all the time. These are keepers, and you can put them back in your closet where you can reach them easily.

Continued →

5 **Pull out items** you don't like, things that need hemming or repair, and clothes that don't fit. Any items you want to donate to charity should be taken off their hangers, folded, and put in the box marked "donate." Items that are in style and in good condition you might be able to sell at a consignment shop; keep these on their hangers and put them in the box marked "sell" or a dry-cleaner's plastic bag.

6 **Look at the pile** you have left over. This is your pile of maybes—maybe keep, maybe donate, maybe sell. To help guide you when going through the items, ask yourself these questions:

> • *When was the last time I used this?* If you haven't used it in a year or more, give it away or sell it at a consignment shop.

> • *Do I love this?* If you do, keep it—and hang it in plain sight where it'll be back in regular wardrobe rotation. If not, you might want to donate it or sell it.

> • *Do I have another one similar to it?* Decide which one looks best on you, and keep that one; the other should be donated or sold.

> • *How does this item make me feel?* If the answer is "Like a million bucks," put it front and center—and find an excuse to wear it more often! Otherwise, consider giving it away or selling it. When in doubt, try it on.

7 **Drag all your shoes out of the closet,** and go through the same exercise above with them.

8 **Pull out seasonal items** from garment bags or shelves in your closet, and pick out the ones you love. These go back in the bag or on the shelf; all the others you need to give the once-over, as described earlier.

9 **Look over your pile of goods to donate,** and feel great! All these things that don't mean much to you can mean the world to someone else. If you have some nice business attire, look in the phone book and online to locate nonprofit organizations for professionals who have lost their jobs or battered women who are getting a new start on life. Fancy dresses can be donated to charitable organizations to raise needed funds or give disadvantaged teens a chance to look and feel special at a school dance.

10 **Assess your pile of items to sell.** If you have a huge pile to sell, you might want to have a garage sale. If you have some vintage clothing items that are twenty-five years old or older, they may fetch a pretty price on eBay. Consignment shops might snap up the latest styles and big designer names, so call and find out when the consignment buyer will available to sort through your items. Put them in separate boxes, and mark them accordingly.

tip

Swap 'til you drop.

If your closet still seems full after this project, consider planning a big clothes swap party with some friends. Everyone brings their castoffs, enjoys some snacks and drinks, and gets to take turns working the runway (OK, your living-room carpet) in new-to-you finery. This is a great way to shed clothes you could live without, rejected consignment items, or unsold vintage scores. Be sure to invite women of all sizes, so no one feels left out of the action. Take turns selecting from each other's piles, and everyone will leave with at least one fabulous fashion find.

Conquer Your Paperwork

Time required: 3 hours

What is it about paper that makes it so tricky to handle? It's not slippery, large, or heavy, and yet it never seems to stay where it's put, spreads out all over the house, and weighs on the mind like nothing else. Almost makes you wish for the good old days, when we all lived in caves where no creditors and junk mailers could reach us—never mind about the saber-toothed tigers and woolly mammoths. But since paperwork isn't about to go the way of the dinosaurs anytime soon, the best thing we can do for now is prevent it from taking over our lives and living spaces. In a single rainy afternoon, you can dig yourself out from under all that paper—and get on top of your bills and correspondence, too.

1 **Hunt and gather your paperwork.** Paper has a tendency to fan out, so you might have to gather it from all around the house, the car, the mailbox, your purse, you name it.

2 **Sort paper into piles:** junk mail, magazines, receipts, lists, bills, and personal correspondence. The temptation will be to open and read your mail right away, but hold off for now. You're just building momentum here!

3 **Recycle the junk mail** without even opening it. You can tell it's junk just by looking at the address label, where these words appear right next to your name: "or current resident." Any company that can't take the time to write to you personally isn't worth yours.

Continued →

4 **Replenish your magazine racks.** Magazines go into a rack in the room where you're most likely to read them, replacing the previous issue. If there's an article you still want to read after the new issue has arrived, tear out the article, and file it in a cheerful folder reserved for pleasure reading that you can enjoy before bedtime or at the doctor's office. (This is a good place for any articles you print out from the Web, too.)

5 **Handle your receipts.** Ask yourself three questions about each receipt, and take action accordingly:

> *Is this purchase something I might return?* If the receipt is for clothing, a gift, or a high-ticket item you might want to return, check the "return by" date at the bottom. That date might be long gone, in which case now is a good time to make peace with your purchase and move on to the next question. But if the date is coming up, add a reminder to your calendar to decide whether the item stays or goes before errand day. Then clip that receipt to your errand day to-do list, or put it in an envelope clearly marked with the "do date" to take with you.

> *Is this purchase potentially tax-deductible?* If it's a grocery or gas receipt, you're probably not going to be able to exchange or return your purchase. But don't toss that receipt just yet: some purchases might be completely or partially tax deductible, such as gas or food bought on a business trip. Any receipts for purchases that might be tax deductible should go in your tax file for the month.

> *Is there any sensitive information on this receipt?* Shredding and recycling all receipts that contain your name, partial credit card number, and signature are smart moves to prevent identity theft.

6 **Consolidate lists.** Gather all the shopping lists, reminders on sticky notes, and reminders on chalkboards and wipe-off bulletin boards from around the house, and make two lists: one master to-do list for the week and a shopping list to go with it. Then schedule in any errands and shopping you're prepared to handle on your personal agenda. Delegate any that you don't have time for to other members of the household, and duly note this on the household calendar. (See chapter 2 for more hints on handling to-do lists and chapter 4 on delegating effectively.)

The Personal Organizing Workbook

7 **Manage your bills.** Put current bills in a bright red folder, and put that folder in the area where you do your weekly accounting. Once bills are paid, you need only keep them until the payment shows up on the next one—unless you're claiming a partial tax deduction for it. In that case, the bill should be filed with the rest of your monthly tax data for the period it covered. But don't hang onto bills indefinitely: you only need to keep financial records for seven years max.

8 **Read through your personal mail.** Now is when you get to sit back, prop your feet up, and enjoy any cards, letters, and fan mail you've received from people or organizations that know you personally. You may appreciate a postcard or note so much that you want to keep it for a while—and that's fine, as long as (you guessed it . . .) you already have a specific space in mind for it. By now, you've probably cleared off a bulletin board or shelf where you can display a very special greeting card. See how organized you are already?!

tip

Always finish one project before you start the next.

Don't go out shopping for a bulletin board while you're dealing with paperwork or decide you're going to get a jump on your holiday shopping with that holiday catalog in the middle of a major mail cleanup. Once you finish one project, you might decide you're on a roll and that you have time to start and complete another—but first give yourself a chance to enjoy the sense of accomplishment that comes from finishing what you started.

streamline your **TO-DO LIST**

"I'm soooo busy . . ." Somehow, this statement has become a socially acceptable form of bragging. We all pride ourselves on our work ethic and love to feel in demand. But is anyone really that much busier than anyone else? And how much are we actually getting done? Are we busy living our dreams, or just busy keeping busy?

According to a recent *Life* magazine survey of Americans, 55 percent of us spend most of our spare time doing chores instead of the things we actually want to do. The study revealed that our top priority for weekends was spending quality time with loved ones—no surprises there, right? But when it comes right down to it, we spend much of our precious weekends grocery shopping, doing office work we've brought home, running miles of errands, and then flopping down exhausted in front of the TV.

After working with many stressed-out clients over the years who felt they were forever falling behind their "busy" schedules, I'm convinced that most of us are spending our days on busywork that we'd be much better off without. Instead of filling our lives

with meaningless chores and the stress that comes with them, we need to focus on the ones that actually count, and save the rest of our time to unwind, imagine, and connect.

In this chapter, we'll start cutting those endless to-do lists down to size, eliminating some tasks and delegating and consolidating others. By the time you're done, you'll get your errands down to one single solitary day a week, and some of those errands will begin to look a lot like—believe it or not—fun. Best of all, you'll finally have some time to call your own. At first you may have a hard time setting aside a few hours of personal time a week when there's so much else to be done, but consider this: downtime is your most productive time. If you want to make big things happen for yourself, your family, your friends, and your world, first you have to give yourself enough time to dream big.

questionnaire

* * *

1 **Are you chronically late?**

Right now, you may be wondering, "How do you define *chronically*, exactly?" You know what they say: if you have to ask . . . But take heart— it's not you that's the problem; it's your schedule. Once you create a schedule you're truly motivated to keep, you'll find that lateness won't be such an issue for you. Jump ahead to page 63 for details.

2 **How often do you forgo sleep in order to get things done?**

From your body's perspective, the ideal answer to this question is "never." As leading scientists point out, the cumulative effect of even a lost hour or two now and again can wreak havoc with your stress levels and productivity. Find out how you can make time for sleep on page 85.

3 **Do you tend to avoid to-do lists?**

If so, you don't know what you're missing! Creating a to-do list takes only a few minutes, and this one small act will fill your entire day with a sense of purpose and accomplishment. Kick your day into gear with the to-do list tips on page 67.

4 **Do you ever feel overwhelmed by your mile-long to-do list?**

The whole point of a to-do list is to make a day's tasks seem doable, so don't expect yourself to get through a long list. Take a hint on page 67 to keep your list short and sweet. You'll be amazed how much more you'll get done with less on your list.

5 **On a good day, how many items on your to-do list do you manage to get through? What about on an off day?**

If you're getting less than a third of your agenda items done, don't beat yourself up about it! Start setting more reasonable expectations for yourself using the tips on page 68, and your track record will improve dramatically. Even days that get off to a rough start will begin to look a whole lot brighter once you start meeting and surpassing your goals.

6 **How many hours a week do you spend running errands, and how much mileage do you put on your car doing it?**

Unless you're a professional shopper who moonlights as a long-haul truck driver, you shouldn't be spending hours every week shuttling between stores and racking up one hundred miles or more on the odometer. Your time is too valuable, and have you seen gas prices lately?! Use the tips on page 72 to save yourself time, trouble, and cash.

7 **What percentage of the chores on your list do you get help doing?**

The best possible answer here would be "all of them." Once chores are shared, they are magically transformed into something else entirely—a chance to learn from others, a bonding experience, a shared triumph. So using the tips on page 73, make your next task a team effort. The Knights of the Round Table and their search for the Holy Grail will have nothing on you and yours, as you set off on your heroic quest to find the source of that suspicious smell in the fridge . . .

8 **Are there certain responsibilities that always seem to fall through the cracks?**

When you're faced with a responsibility you tend to avoid or even dread, remember these words: *delegate* or *eliminate*. The tips on page 73 will help you hand off responsibilities gracefully, and concentrate on the ones that are most rewarding for you.

The Personal Organizing Workbook

9 **Do you miss an appointment, birthday, or special event you meant to attend once a week, once a month, or once a year?**

Once in a while is understandable, and even advisable. When your schedule is particularly hectic, something's got to give. But the key word here is *schedule*. If you schedule all your social commitments on a calendar as described on page 75, you won't accidentally miss out on a good time—and if you have to send your regrets, you can do it in advance and stay on your host's invite list. Let the good times roll!

10 **How much actual downtime do you have a week, when you're not doing chores, running errands, or fulfilling some responsibility?**

If you're counting your downtime in minutes rather than hours, try the project on page 82 to start reclaiming your personal time.

11 **How many days a week do you start the day feeling rushed?**

OK, this was a trick question. If rushing is habitual for you, that's ongoing stress you'd be better off without. Flip to page 87, and get tomorrow off to a good start today.

Common Problems—and Solutions

Many people dread to-do lists and appointment books, and that's understandable—they do require a few minutes of upkeep every day, and long lists of tasks and packed schedules can be daunting. But a short and sweet to-do list and longer-term appointment calendar can actually be time-savers and stress-savers, too. Listing a few well-chosen action items and key appointments will spare you precious time wasted racking your brain trying to remember what you were supposed to do, not to mention the guilt of neglecting an important commitment or chore. The time-management tips in this chapter will help you to get done with your tasks, and get back to your previously scheduled life!

I'm running behind schedule . . . again.

How many times have you heard someone say in a panic, "I don't have enough time"? How many times have you said it yourself? We all keep pretty busy these days, and yet certain people don't seem to be bothered by it. You know the ones: they're your neighbors who host a Halloween haunted house for all the neighborhood kids, or the friends who volunteer to pick you up from the airport, or the go-to parents in the local PTA who always bring cookies to meetings. Not only are they able to find the time for these things, but they actually seem to enjoy making all that extra effort.

So what medication are they on? Could all those cheerfully busy people secretly be robots? Happy productive people do have a secret, and here it is: they don't let their lives become ruled by what they *have* to do. They've figured out what they *want* to make happen—a party, an uninterrupted conversation with a friend, a better school for their kids—and managed their time accordingly.

With an inspiring personal goal in mind, you can get less bogged down in everyday tasks, and you'll have an incentive to finish them faster so you can move on to more important matters. Once you strike a better balance between what you need to do and want to do, you'll have a schedule you'll really want to keep. So what are you waiting for?! Get started on the next page.

Write a "want-to-do" list. Start by listing activities that make you happy, and you'd like to do in the next week: reading, hiking with a friend, trying out a new recipe. Then let yourself daydream, and come up with a few longer-term dreams. Maybe you'd love to learn fly-fishing, or you've always dreamed of writing a novel. Write down that long-term goal as well. You're going to start making that dream come true this week, whether that means Web surfing to get a good price on fishing poles or finding that perfect cabin in the woods you could rent for a wonderful writer's retreat weekend.

Calendar it in. On a calendar, make dates to pursue the items on your want-to-do list. Then, and only then, you can start scheduling in the items on your must-do list: laundry, grocery shopping, accounting. But remember: just buying a calendar won't automatically get you organized. Here's what it takes:

- *Record every time commitment you make,* including social events. That way, you'll have an incentive to get work over and done with, and you'll finally get a chance to unwind.

- *Check your calendar regularly*—even when you don't think you need to. That's exactly when your trusty calendar is most likely to remind you about an appointment you'd forgotten about completely.

- *Get a calendar that's convenient and even fun* for you to consult. Go with what works for you, whether that's a glossy wall calendar with stunning photos or inspirational quotes, a handheld digital device with musical reminders, or a small week-at-a-glance calendar that fits in your pocket.

- *Make sure you have enough space* in your calendar not only to record all your appointments and activities but also to make notes and list projects that occur to you in the course of the day. Don't let that bright idea or sudden stroke of genius escape you!

- *Families should keep a wall calendar,* so everyone can keep track of family events and shared responsibilities.

Improve your on-time arrival record. Here's a trick every airline uses: to make it where you want to be on time, build a time buffer into your schedule. Set your clocks and watch three to seven minutes ahead. On your calendar, mark your appointments a little earlier than they really are. Have a clock in every room—even the bathroom.

When you're working on a deadline, set a kitchen timer for fifteen-minute time slots. The bell will help keep you on task and on time. You can even ask a friend to pick you up or call to get you headed out to an appointment.

玉
宮
殿

	Sunday *Domenica*	Monday *Lunedì*		*Iay* *ì*	Friday *Venerdì*
	1	2			6
	8	9			13
	15	16			20
	22	23			27
	29	30			

I'll never get through my mile-long to-do list.

Believe me, I know how you feel . . . and so does at least half the country. The staggering to-do lists we set for ourselves are enough to wear out even the perkiest youngsters—according to the *Life* magazine study, half of adults aged eighteen to twenty-four end their weekends feeling exhausted rather than recharged.

Now here's the good news: today's the day you're going to beat those odds. Start by taking a long, hard look at your most recent to-do list. Which of these line items are rewarding, which seem to have a permanent place on your to-do list, and which ones just make you groan? You want more of your list to fall in the first category, fewer in the second one, and none at all in the third category.

How are you supposed to do this? Simple. Prioritize, set reasonable goals, make tasks as fun as possible, and make "no" an active part of your vocabulary. Despite what you may have heard, you don't actually need a fairy godmother to get done with your chores and start having a ball. Once you put the tips on pages 68–69 to use, you'll discover that you have the power to change "to-do" to "ta-da!"

Consolidate your lists.

A client of mine recently made my day by sharing this time-management triumph: "I used to keep several to-do lists in different places. If I was sitting in the kitchen and thought of something I needed to do, I would write it down on a little scrap of paper. Then I'd have scraps of paper in all the rooms of my house! Now, I write everything down in one book. If I'm on the phone and somebody asks me to do something, I say, 'Hold on a minute, let me get my book.' That way, I don't find myself scrambling to keep track of little slips of paper or trying to remember all the things I'm supposed to be doing."

Make transactions into pleasant interactions.

You know that sign that says "We reserve the right to refuse service to anyone"? That's your reminder that the service people behind the counter at the store, café, or toll booth aren't technically *obliged* to help you. So when they go above and beyond by being pleasant about it, return the favor by making their jobs a little easier. Crack a smile or a joke, try some small talk, and acknowledge their presence by looking these helpful people in the eye when you talk to them. It's just a small gesture, but that friendly exchange could be the start of a good mood that sees the both of you through your day. One day we might have to deal with machines instead of people all the time—so we really should make the most out of human interaction while we can, whenever we can.

Make your priorities into urgent action items. Instead of getting waylaid by minor tasks and time fillers, put your priorities right up at the *top* of your list, where you can't miss them. If your main priority right now is your love life, your career, your family, or your friends, turn that into an action item: a romantic evening, a killer boardroom presentation, a family Monopoly marathon, or a heart-to-heart with a friend you haven't seen in ages. Plan that action item for the time of day when you're at your best. Then schedule your other tasks to accommodate your goal. In the time it takes to do a few laps around the grocery store or watch a so-so movie, you'll be making a memory.

Set reasonable goals. Sometimes you amaze yourself with how much you can get done—but don't count on that happening all day, every day! We all get tired eventually, and factors beyond our control interfere with our best intentions. So:

• *Break down projects* into manageable tasks that take half an hour or less to complete. That way, if you only have half an hour to spare between appointments, you can still cross one thing off your list.

• *Be realistic* about how much time a task is likely to take. To come up with a reasonable estimate of how much time you need to accomplish a task, add up your most optimistic estimate and your worst-case scenario and split the difference. Then tack on a time buffer. For example, if you know doing the dishes takes just ten minutes when your kids or roommates actually remembered to run and empty the dishwasher, and up to forty minutes when they didn't, give yourself thirty minutes for the job. You'll stand a much better chance of getting the job done—and you're a lot less likely to get into an argument about the dishes that spoils the rest of your day.

• *Minimize multitasking.* It's a myth that multitasking automatically makes you more productive. Satisfaction comes from a job well done, not three shoddy jobs done in record time. Concentrate on one responsibility at a time, especially those that are near and dear to you. You don't want to miss the moment your kid scores a goal because you're on your cell phone with the plumber or let a lovelorn friend overhear you tapping out an e-mail when she's pouring out her heart to you over the phone. Combine only easy tasks or ones that don't require your undivided attention, such as doing laundry and filing your nails or making a to-do list while waiting for the bus.

• *Get on a roll* by grouping similar tasks together, like making phone calls or writing thank-you notes. This can reduce a list of ten tasks to three and make it seem so much less daunting. Getting started is always the hardest part.

- **Don't try to do it all.** If you can complete three of eight items on your list and know you've given each one your best effort, cross them off with pride. Look at it this way: how many tasks do you think you would have gotten done if you hadn't bothered to make a list and set up a schedule? Whatever you didn't get to accomplish today can be bumped to the top of your list for tomorrow, if you decide it's that important. And if you accomplished an urgent-action priority today, that might be a more important accomplishment than three lesser items combined. Think quality, not quantity.

- **Get a jump start on tomorrow today.** Create your next day's to-do list the night before, when you've got a clear head and are riding high on your sense of accomplishment from a good day's effort.

Cut down your list. You'll have fewer tasks to worry about if you:

- **Quit saying maybe** when you really mean no. It may be hard to say no, but it sure beats disappointing people who are counting on you to follow through when you really don't have the time or inclination to do so. A gentle but firm no is always better than a weak yes. (For more on when and how to say no, see chapter 3.)

- **Negotiate.** Just because your boss approached you with a task, don't assume you have to drop everything, hop to it, and cancel your dinner plans to stay late. Instead of asking "When do you need it?" first get the priorities straight, and make the consequences clear: "Well, I'm just finishing up that sales report that's due on Friday. Did you to want me to

hand that off to someone else or push it to next week, if that's OK by the people in accounting?" Instead of taking on an undue burden, try to find a solution that works for everyone: "If accounting wouldn't mind fact-checking these sales report numbers, I could get to it by Thursday."

- **Graciously decline.** Sure, it's an honor to be asked to serve on the board of directors of the local ballet company—but do the math on those meetings before you agree. Are you prepared to sign away two nights a month for the entire length of a two-year term? This is what people mean when they say, "The honor is too great." Find a volunteer commitment that fits into your schedule, and you'll get so much more out of it.

Make every task as fun as possible. So you have to stock up on suntan lotion? Take a minute to consider how you could make that ho-hum task more fun. You could:

- Call up a pal who'll try on wacky sunglasses with you as you troll the sun-care aisle at the drugstore.

- Build a bigger time buffer into your schedule, so you can take a few minutes to check out funny birthday cards, or flirt with that cute pharmacist.

- Go to that little mom-and-pop drugstore in your neighborhood, instead of the huge one with the surly staff and the humming fluorescent lights across town. It's worth paying a few extra cents for your lotion if it saves you gas and a headache.

It seems like my job is never done.

Now here's a problem that's been around at least as long as there have been office jobs, and quite possibly ever since the very first mom walked the earth. But you're going to solve it today. Yes, you! Just take a deep breath, and let's take another look at that classic problem you just described.

When did you plan to get it done?
What is the job, exactly?
And **why** is it your job?

If you're stumped by any of these questions, that's your key right there. Planning ahead, staying focused, and delegating are indispensable when it comes time to get things done. You could have twenty-five hours in a day and still not get as much accomplished as you do in a single hour you've set aside to concentrate on a task with all the support you need. You may find you have time left over to take care of some other bit of business (see facing page), or stare out the window and watch the clouds go by—maybe even call your mom.

Make use of stolen moments.

In five minutes you can:
- Make an appointment.
- Buy a birthday present online.
- Water the plants.
- File your nails.

In ten minutes you can:
- Make a phone call.
- Dust your bedroom.
- Clear your desktop.

In thirty minutes you can:
- Exercise.
- Balance your checkbook.
- Plan a *fun* weekend!

Make big changes in just a little time.

I know what you're thinking: "How can I change the world when I don't even have time to do my laundry?!" Simple:

Make a pact to get things done. The election's coming up, and you don't know all the local candidates. Believe me, you're not the only upstanding citizen in this predicament. Make a pact with a few friends to research one candidate's platform each, then get together and compare notes.

Get results fast online. Wonder why your city doesn't require all waste-management companies to recycle every type of plastic waste? Your answer may be only two clicks away: go to the city's Web site, click on the "staff" button, then click on the contact e-mail for the community-relations rep, and drop a line asking about plastic recycling. You should get an answer within forty-eight hours. If you're not satisfied with the answer, forward your e-mail with your comments to a reporter at your local paper—their contact e-mails are usually online, too.

Plan ahead. How many times a week do you go to the same store, run the same errand, or cover the same stretch of road—and what does that cost you in time, gas money, and frustration? Try limiting errand runs to once or twice a week instead. To prepare for the big day:

● *Keep a voice recorder or a pen and paper handy* during the rest of the week so if you think of anything you need to do, you can make a note of it.

● *Double-check* to see that you have all the ingredients you need for recipes, and add any items you need to the grocery list. If you prefer to get your fresh produce from the farmers' market, keep a separate list for those items, and make sure your errand day coincides with the farmers' market.

● *Get an entire week's meals covered* by buying grocery items and basic necessities in bulk, and you'll save yourself time and money. You can load up on fresh produce and locally made jams, honey, cheeses, and baked goods at your local farmers' market; cereal, beans, pasta, rice, nuts, spices, and nut butters at natural food stores that sell these items by the pound; and toilet paper, soap, cleansers, and the like at a food club that sells discounted items in bulk.

● *Draft a plan of action for the big day.* Map out your errands geographically so you are going to the farthest place first and working your way back home. Set up Errand Day Headquarters in a convenient central location, whether that's at a coffee shop or in the school parking lot while waiting for the kids. This is where you will take a breather, make any phone calls to confirm appointments or check opening hours, and go over your list to see what you still need to do and what needs to be rescheduled for a later date.

● *Keep track of your mileage* on your odometer, and see if you can cover as little distance as possible on your errand route. Every mile you save on your car is a minute saved, some extra change in your pocket, and a favor to the environment.

● *Set out your clothes and breakfast* the night before, so you can get your day off to a smooth start.

Stay focused. Once you've got errand day off to a good start, keep it up!

● *Do what you can* . . . no more, no less. If you can't get through a big, tough project today, break it down into manageable half-hour tasks, and get one or two of those done today. Then schedule time to do the other ones. Once you get started, you may find it's easier than you expected.

● *Minimize distractions.* If you can't help answering the phone when it rings, unplug it. If the TV, Web, and e-mail are temptations, work in another room.

- *Tell other people what you're up to.* Once you tell others what you're planning to get done, you'll want to keep your word. Plus you'll get encouragement, and people will know not to bug you. To really prevent interruptions, hang a sign on the door to your work area that says MAYBE LATER—and if that doesn't work, try the blunt but effective NOT NOW.

- *Keep the momentum going.* Once you've finished a task, give yourself a minute to get up, stretch, and pat yourself on the back. Then ride that sense of accomplishment right into your next task. If you can do this a few times in a day, you'll be limbered up and on a roll.

Don't try to do it all yourself. If you could manage everything by yourself, that would make you either a superhero or a demigod. So unless there's some very big secret you haven't been sharing with us, start sharing the responsibilities. Here's how to delegate like a pro:

- *Create a chore board* with rotating assignments for everyone in your household . . . hey, that's why they call them *household* chores! Hang it in plain sight, so everyone knows what he or she has to do. Establish a regular routine so that chores get done the same time every week, and make sure everyone in the household gets to contribute to the effort—no matter how small. Psychologists report that entrusting kids with household responsibilities does wonders for their self-esteem, so don't leave them out of the action. Give them an allowance in exchange for their chores, and they'll learn a work ethic that will serve them well throughout their lives.

- *Trade tasks.* If you're facing a task you're just not confident about getting done well, consider swapping with someone who has skills and interests in that area. Maybe you can help your friend build her Web site, and she can help you update your résumé. Bonus points: watch over one another's shoulders, and learn how it's done.

- *Divide and conquer common tasks with friends.* You and your friends have a lot in common—including tasks. Apply the divide-and-conquer rule to common tasks like carpooling, child care, and holiday shopping.

- *Ask for a favor once in a while.* Someone else in your family might not mind polishing the silver, and that bored intern at the office might be happy to do some Web research for you.

- *Accept help graciously.* Everyone likes to feel needed. So take your friend up on that offer to pick you up for the movies—that's what friends are for! You can get the popcorn, and everyone's happy.

- *Pull a Tom Sawyer.* Remember Mark Twain's hero, who convinced people that painting his fence was so much fun that everyone wanted to do it? The same logic applies to real-life painting parties, moves, neighborhood cleanups, and barn raisings. Hint: it never hurts to offer pizza as a bonus.

- *Get professional help.* We all have errands we put off for as long as humanly possible. You know the ones: dentist's appointments, bathroom cleaning, bills, taxes, and, yes, organizing. Any professionals you hire to help you with these errands should make them less daunting—if not, maybe you need to hire someone else instead.

Update Your Calendar

Time required: 1¹/₂ hours

To really take charge of your time, first you have to take charge of your calendar. Mapping out your month will let you see at a glance what the coming weeks have in store for you, so you don't miss or double-book appointments. Then, once you're on top of your schedule for the month, you can think ahead to the coming months, and plan for birthdays, anniversaries, and vacations. Get the rest of your household on the same page with a household calendar, and you'll never be caught unaware of another dentist's appointment, dinner party, or soccer game. But whatever you do, be sure to leave some empty spaces on that calendar—the point of keeping a calendar isn't to have a full schedule, it's to have a full life!

1 **Invest in a weekly calendar**, a handheld electronic organizer (also known as a PDA, or personal digital assistant), or a daily date book, if you don't already have one—and if you're not crazy about the one you've got, consider an upgrade. This is one item you're going to be looking at several times a day for a year or more, so you should have one you really, truly like; check out "Date Books and Electronic Organizers" on page 161 to explore some options. Make sure it's small enough that you can carry it with you at all times. Choose the type that suits you and your lifestyle best:

- A convenient, pocket-size week-at-a-glance calendar

- A slightly bigger week-at-a-glance calendar, featuring different art and inspirational quotes every week

- A stylish, leather day-at-a-glance date book, with time slots for every hour of the day and extra pages for notes and recording expenses

- A slim, sleek handheld electronic organizer with a calendar program, a database for addresses and phone numbers, and expense report software

- A handheld electronic organizer that offers all the above software features, plus instant access to e-mail and a built-in phone, too

With so many dazzling features and options available, you may be tempted to buy more than one—but resist that temptation! The problem with having more than one calendar is that it's way too easy to forget to transfer information from one place to another. This is how appointments slip through the cracks.

2 **Calendar your month.** Check e-mails, phone messages, to-do lists, mail, invites, old calendars, memos, scraps of paper—anything that might contain an invitation, an appointment, or an important date. Once you've collected these, get out your calendar, and get to work:

- *Write in ink all the commitments and appointments* you have already made (work-related events, dinners, lunches, brunches, girls' nights out, parties, showers, weddings) plus any special events you absolutely, positively don't want to miss (movies, performances, sports matches, concerts, book signings, art openings, recitals). When recording an appointment, include the address, contact telephone number, and directions in the space next to the appointment.

- *Jot down in pencil any tentative plans* you've made (even in passing). Then schedule a time a couple of days before that to check in with the people with whom you've made those plans to confirm, reschedule, or cancel. If your calendar is detached from your address book, next to each follow-up call you schedule you'll need to make note of a phone number where you can reach that person.

- *Note any standing appointments* on your calendar, too. This includes birthdays, anniversaries, workouts, classes, weekly meetings, and dates when bills are due. Even a regular Friday lunch date with friends should be noted so that when a busy Friday at the office rolls around, you won't forget about your friends.

- *Take a minute to review next week's schedule,* so you know exactly what's coming.

Continued →

3 **Start planning ahead,** now that you've got the hang of this whole scheduling thing. In addition to birthdays and anniversaries, you can make note of things you'd like to do every month. Add in seasonal plans as you go, and when you're through, glance over last year's calendar to make sure you haven't missed anything.

Seasonal plans to put on your calendar:

Spring

- The perfect excuse to make a clean start—plan your household's spring cleaning.
- Plant a garden now, and enjoy flowers, fresh herbs, and home-grown tomatoes this summer.
- Research summer camps for the kids.
- Keep a picnic basket and blanket handy, so you can make the most of a sunny afternoon at a moment's notice.
- Make sure the air conditioner is up and running. Changed that filter lately?

Summer

- Get in gear for summer vacations, and check all camping and sports equipment *before* you hit the great outdoors.
- Hit the summer fair and festival circuit.
- Hot enough for you? Beat the heat with a weekend getaway.

Fall

- Stash summer items, and bring out those cozy sweaters.
- Finish up household repairs before bad weather arrives.
- Get your flu shot before flu season hits.
- Winterize your windows, and check your car tires.

Winter

- Go out, in this weather? Plan to entertain friends at home instead.
- The perfect time to curl up with a good book, and organize a book club.

Continued →

The Personal Organizing Workbook

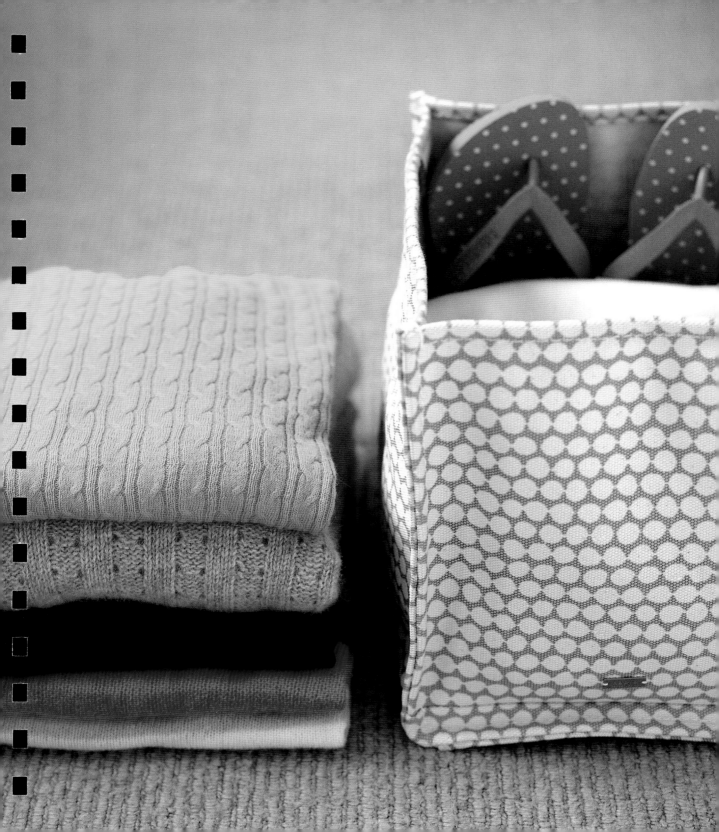

Monthly plans to put on your calendar:

January

- Buy holiday ornaments, cards, wrapping paper, calendars, and champagne at half price!
- Collect tax info.
- Take advantage of white-sale month, and stock up on sheets.
- Plan a getaway for a long weekend—maybe someplace tropical?

February

- Join the gym for the month, now that the New Year's resolution rush is over.
- Snuggle up with some romantic comedy flicks to get in the Valentine's Day spirit.

March

- Plan for Easter and Passover.
- Reorganize your clothes closets—if you didn't wear it last year, get rid of it!

April

- Celebrate Earth Day by biking or taking the bus, recycling, and planting a tree.
- Take a friend out to lunch, just because.

May

- Send your mom a card to let her know you're thinking of her—and while you're at it, stock up on cards and stamps.
- Get gifts for grads—and end-of-year presents for teachers.

June

- Hint: Dads deserve treats, too. Give yourself enough time to find the perfect present this year, and give the guy a welcome break from the usual ties and aftershave.
- Mmmmm . . . berry picking!

The Personal Organizing Workbook

July

- Seen anything good lately? Ditch the cineplex blockbusters, and plan an outing to a concert or play instead.
- Now is a fine time for a garage sale.

August

- Stock up on school supplies and clothes before the rush.
- Don't stress out just because your August holiday is ending—make plans for a September getaway instead.

September

- Review goals to accomplish before the year's end, and set your schedule accordingly.
- Start holiday shopping early—like now.

October

- Declare your own Get Organized Week: pick a project in this book, and have at it!
- Choose your Halloween costume, or even make it yourself. Who says kids get to have all the fun?
- Hosting a big family feast? Start planning—and delegating—now.

November

- Don't let the holidays sneak up on you: plan your menus, take holiday photos to send to family members, and make your holiday card list.
- Plan a long weekend out of town to chill out before the holidays (and all those guests!) arrive.

December

- Mail those cards and gifts early this year.
- Bake holiday cookies, and make your helpers happy—mail carriers, babysitters, and the neighbors who loaned you that cup of sugar in the first place.
- Dream up a scheme to ring in the New Year in style.
- Resolve to be this organized next year, too!

Continued →

4 **Get a wall calendar.** If you live with other people—your family, room-mates, a loved one—you can keep track of shared social engagements and one another's whereabouts. Hang this in the kitchen or some other high-traffic communal space, and encourage everyone to update it at least weekly. That way, you'll never be left wondering where your roomie is when she's off on a business trip, and you'll know it's your job to walk the puppy when your spouse is off at a tennis lesson.

tip

While you're at the stationery store, stock up on greeting cards.

Blank cards will always come in handy, and so might these cards:

- Thank you
- Birthday
- New baby
- Wedding
- Anniversary

Put these in a special file or drawer at home and the office so they're handy whenever an occasion arises. People will be so touched by your thoughtfulness—and all it really takes is thinking ahead.

Reclaim Your Personal Time

Time required: $^1/_2$ hour

Need some personal time to recharge and reflect? Don't we all! As any doctor will tell you, this is an important way to take care of yourself and manage stress—and it'll help you appreciate and care for others, too. Problem is, although many people crave time for themselves, few actually schedule it. Instead, they fill any and every gap in their schedules with errands and social engagements. But with nothing more than a calendar, a pen, and a phone, you're about to break away from the daily grind and show the world how fun gets done.

1 **Look for gaps in your calendar.** Is there an hour next Saturday between your doctor's appointment and the time you have to meet with a real estate agent? Block that off right now, and write "PT" (personal time) in that time slot. Why bother? Because if you don't, you might commit to another errand in that time period. Then, instead of taking a lovely walk in the park or casually browsing a bookstore, you could wind up attending a neighborhood-watch meeting that runs long or frantically shuttling kids from soccer practice to a birthday party across town. Before you know it, you're late for your meeting with your real estate agent. Save yourself the stress, and give yourself permission to live a little!

2 **Take time off work.** If you work in an office, pick a day in the next few weeks when your workload will be low, and arrange with your boss and coworkers to leave early or come in late that day—or not at all. You don't need to come up with an excuse; that's why they call them "personal days." As long as your workload is covered, there shouldn't be a problem with you taking a few hours off (and if there is, maybe you need a new boss!). When the time comes, you can return the favor by covering for your coworkers for a day. Moms, you're entitled to a day off work too—so arrange for your partner, a relative, a friend, or a babysitter to cover a child-care shift. Again, there doesn't have to be a reason given. If anyone asks why you need personal time, just smile

and say, "Maybe you'd like to babysit?" Make a definite decision as to how you want to spend your day off, or it will simply slip away from you. Do you want to spend it alone? With family or friends? What sort of activity do you want to do? For inspiration, you can rent the movie *Ferris Bueller's Day Off.* In it, Matthew Broderick plays hooky with friends and catches a fly ball in Wrigley Field, dines on pancreas at a fancy French place, gets lost in impressionist paintings at the Art Institute of Chicago, and joins a parade. (Dare you to top that!)

3 **Find time in your packed schedule,** even if you have to beg, borrow, or steal it. Look over your schedule for tomorrow, and try one of the following to find a moment's peace in your day:

> • *Beg off commitments* you made before your schedule got so out of control. Try saying "It's been such a crazy week. Could we do this another time?" Or "I just can't give this the attention I'd like right now. Maybe we could reschedule?" There's always the old standby: "Would you mind terribly if I took a rain check?" Take advantage of this chunk of time to do something you wouldn't ordinarily do—take a dance class, hit some art galleries, try out a new restaurant with a new friend.

> • *Borrow time* while waiting in your doctor's office, during a bus or train ride, waiting at a restaurant, or following a canceled appointment. Flip through a magazine, listen to an audiobook, write a poem . . . whatever moves you.

> • *Steal an hour* from sleeping time by getting up earlier than usual or staying up later, and plan something fun or rewarding for that time so that you'll be motivated to follow through. This is a great time for a craft project, journal writing, or yoga.

Continued →

4 **Buy time.** With a few bucks, you can pass the buck and spare yourself time and trouble. Take a few minutes to surf the Web, and explore the options in your area:

- *Save yourself the trip.* Use pickup and delivery services for video rentals, prescriptions, dry cleaning, and more.

- *Contribute to a college fund.* Pay a teenager or college student to rake your leaves, clean, or move furniture.

- *Arrange house calls.* These days, exercise trainers, hair stylists, and manicurists will come to you if you can't make it to them.

- *Enjoy your yard for a change.* Hire a groundskeeper to mow the lawn or shovel the snow, so you don't have to.

- *Go gourmet without going anywhere.* Dinner chefs, personal nutritionists, caterers, and restaurants will whip up scrumptious home-cooked meals and fabulous dinner parties for you.

- *Kiss retail good-bye.* Let your personal shopper pick out great outfits and holiday gifts. Why hunt through the racks, wait in line, and get stuck in traffic?

- *Earn money without even trying.* Hire a financial planner to set financial goals, manage your portfolio, and create a nest egg.

5 **Make a weekly date with yourself.** Now that you know how great it feels to take a breather from your airtight schedule, this should be a no-brainer. Take out your calendar and schedule in personal time (in ink!) in a regular time slot once a week, every week, for the next month or two. To be sure that nothing interferes with your plans, check that there are no major time conflicts that you can foresee: family vacations, business trips, you name it. You might consider signing up for a fun class— fashion design or learning Italian, say—if that will help you take your personal time commitment more seriously. Now take a look at your schedule, and see how many times "PT" appears. Each one is proof that you value your own time, your health, and your personal growth—and you know how to have fun, too!

The Personal Organizing Workbook

Beware time bandits.

These notorious habits will rob you of your free time,
so watch out for them:

- Taking on more tasks than you can possibly handle
- Never delegating
- Losing sight of your top priorities
- Neglecting to set yourself a deadline
- Not having the tools you need on hand before you start a task
- Being interrupted by visitors who just drop in
- Leaving unfinished tasks to be completed at some unspecified later date
- Watching television when you had planned to do something else
- Compulsively checking e-mail

Make time to sleep!

If you have a big day tomorrow, don't forgo sleep to get a jump start on
it tonight. According to the U.S. National Sleep Foundation, losing sleep
makes us less effective at tasks for days afterward. Instead, try these tips
for a good night's sleep:

Exercise regularly. Deep sleep comes more easily to a tired body. Be sure
to finish your workout at least three hours before bedtime, though, so
your body gets a chance to come down from that exercise high.

Give sugar, caffeine, and alcohol a rest at least a few hours before bed-
time. If you're hungry before bedtime, healthful snacks are best, so your
body isn't trying to metabolize heavy foods when it should be resting.
Smokers should lay off the cigs before bed, because nicotine can make
falling asleep difficult.

Make your bedroom a sanctuary. Don't bring work to bed with you; try
a novel instead. Before you nod off, fluff your pillows, turn off the TV, and
make sure it's dark, cool, and quiet (put in some earplugs if you need to).
Sweet dreams!

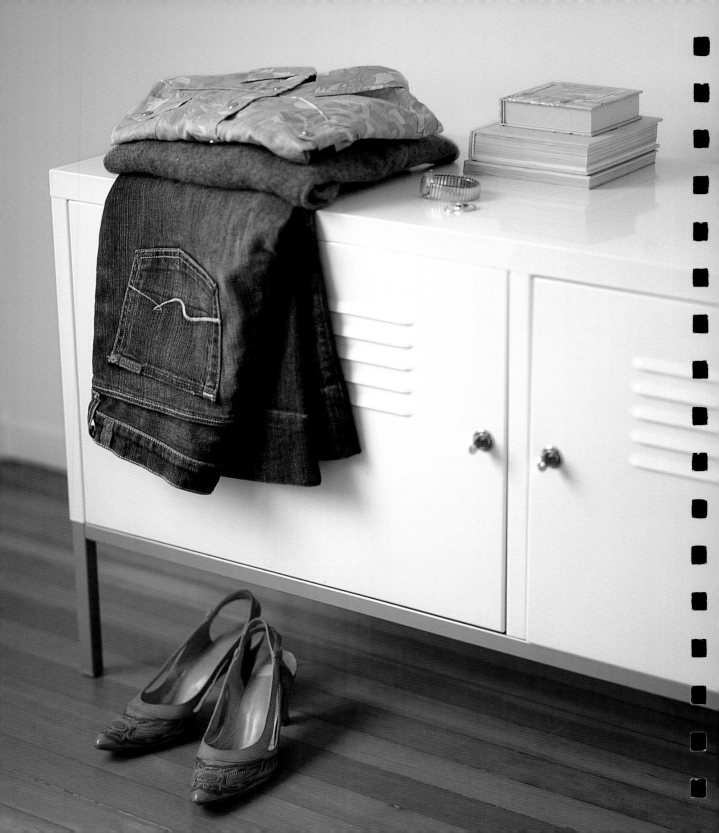

Get a Head Start on Your Day

Time required: 1 hour

A great day starts the night before. Even if you're sleepy, a few basic steps now will get you off and running tomorrow. Then, when you're up and raring to go, there's nothing holding you back. Stay calm, collected, and—most important of all—organized amid the morning rush, and you'll set yourself up for success for the rest of the day.

The Night Before (1/2 Hour):

1 **Set your alarm clock an hour early, and go to bed that much earlier.** You'll be surprised how much you can accomplish. Due to cycles of sleepiness and wakefulness called circadian rhythms, our bodies are naturally ready to wake around 6 to 8 a.m. and start getting ready for bed around 8 p.m.—and who are we to argue with our bodies? Obey your body, and maximize those peak hours.

2 **Lay out your clothes the night before.** If your closets are organized, this is an easy task (see page 45 for advice on this one). Make sure all your clothes for the day are ironed, laundered, and mended and that your shoes are shined if necessary.

3 **Put your keys near the door in plain sight,** and you'll never have to worry about those frantic, last-minute key hunts again. If you don't have a hook in the front hallway, pull out a pretty dish you can use to hold your keys, and put it on a shelf or table near the door.

4 **Set the breakfast table.** That way, you're more likely to have a moment to sit down and enjoy your breakfast.

Continued →

5 **Pack your purse or briefcase,** and leave it in a convenient spot by the coat closet or front door. You might also want to leave out your coat, scarf, gloves, hat, and anything else you need for a quick exit.

6 **Designate a spot by the door for all items needing repair or cleaning,** so they can be picked up on the way out. Once you put them there, make sure they are taken out of the area within two days.

7 **Set your departure time.** Think about your morning routine and how many minutes each task will take. To that add travel time and an additional buffer of fifteen to twenty minutes for traffic and the unknown. This will allow you to plan exactly how much time you need to get out of the house and to your final destination on time. Then set an alarm near the door (or on your watch or cell phone) for five minutes prior to departure, just to be sure you get out on time.

8 **Go to sleep!** Nothing gets your day off to a better start than a good night's rest.

In the Morning (1/2 Hour):

1 **Make your bed** as soon as you get up. That way, you won't be tempted to crawl back into it . . .

2 **Shower before anyone gets up** to avoid the a.m. rush to the bathroom. One side benefit of being an early riser: the hot water will never run cold on you.

3 **Screen morning calls** so you don't get bogged down by a conversation that could be held later in the day.

4 **Take it one room at a time.** Don't hop from room to room as you get ready. Finish everything you have to do in one room before you move to the next. Tidy up as you go, and take your coffee cup with you.

5 **Call to confirm** your appointment before you leave home, and double-check that the person you are seeing isn't running late. Never assume that other people are as organized as you are.

6 **Ask yourself: "Can this wait?** Does this really have to be done now to get me out the door?" Repeat this question as necessary until you are out the door. Things that can wait: doing the dishes, putting on lipstick, even tying your shoes. Things that can't: putting on some clothes (unless you want to get arrested) and (let's be honest here) drinking coffee.

tip

For a.m. parenting:

1. Have standing backup arrangements in case one of your school-age children is sick or the babysitter is late or a no-show.

2. The night before:

- Lay out kids' clothes. Get their input now, so you don't have to hunt for that Superman cape to calm your kindergartner when you should be out the door.
- Make their lunches for school. By taking a few minutes to make a sandwich, chop some veggies, and fill a thermos with milk, you can ensure your kids eat right and save money, too.
- Restock the diaper bag as needed. Imagine trying to find a clean diaper when you're halfway through the diaper change—need we say more?

Leave extra time for the element of the unknown, a.k.a. parenthood.

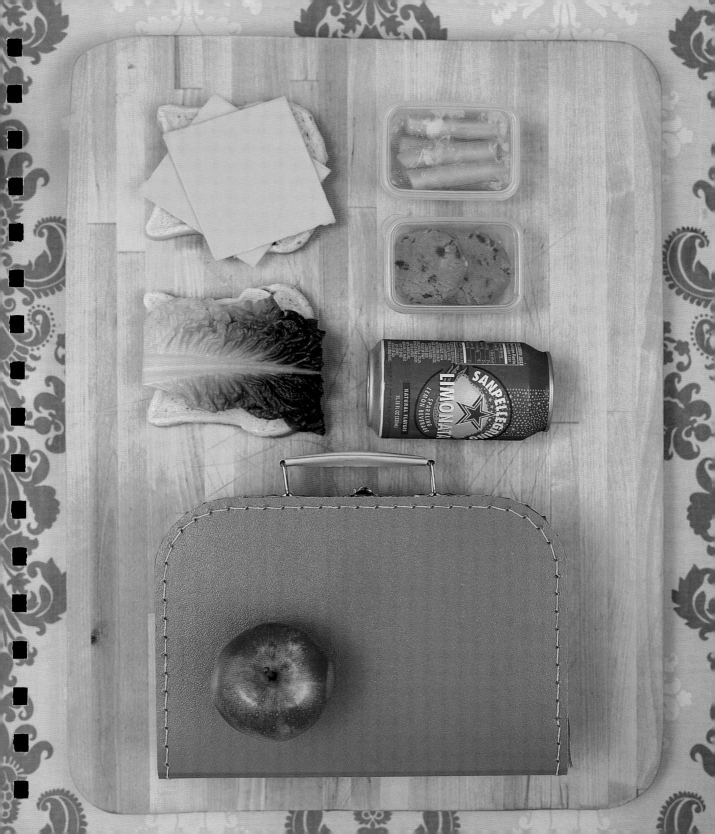

manage your **RELATIONSHIPS**

Glance over your calendar, and notice who takes up most of your time. If you're like most of us, your social schedule is loaded with family obligations, work-related social commitments, events friends are dragging you along to, dreaded appointments, and iffy Internet dates. Now, think of the people who really intrigue you, inspire you, and make your heart do handsprings. Where do they show up on your calendar? Maybe your nearest and dearest make an appearance as special guest stars during that all-important ten-day stretch marked *vacation*. Ten days to catch up on the most personal aspects of your personal life, out of a year? It's just not enough.

Problem is, we tend to take our closest relationships for granted and waste precious time on social obligations that are personally unfulfilling. In working with clients, I've noticed that even hyper-organized people with color-coordinated closets struggle with this one. We might be able to match our shoes to our outfits, but matching our schedules to our relationship priorities? Now *that's* an organizing challenge. But it can be done— and this chapter will help you do it. Yes, you!

First, we'll deal with the people who take up more time than you really have to spare, or are best in small doses. You'll learn exactly when to say no to new commitments and how to bow out gracefully from ones you just can't manage—because the best way to maintain happy, fulfilling relationships is to make sure you're not overcommitting in the first place. In the process, you'll make time for new people and inspiration in your life, and you'll finally enjoy some quality time with the people who mean the most to you.

By the time you finish this chapter, you'll have standing dates with people you enjoy and time to throw a relaxed dinner party for friends both new and true-blue. You'll have no fear when consulting your social schedule—instead, you'll see at a glance just how much you have to look forward to.

questionnaire

1 : **Do you ever feel overwhelmed by your social obligations?**

Social events should be optional—once they become obligations, they're just a drag. Start opting for more fun and less work with the tips on page 104.

2 : **This month, do you have plans with anyone who you're not especially looking forward to seeing?**

Live and learn . . . Find out when you need to take a breather from a relationship, and how to scale back a relationship so that it fits within your set of personal priorities. Page 104 reveals all.

3 : **How much of your downtime each week is spent with people you actually enjoy?**

The number you're shooting for here is 100 percent, including the time you've set aside in your schedule to enjoy your own company. If this ideal isn't exactly your reality, use the pointers on page 110 to make incidental social interactions shorter and sweeter. That way, you'll have more time and positive energy left over for the people in your life who matter most.

The Personal Organizing Workbook

4 : **What dates on your social calendar are you looking forward to most this month?**

You need more dates like those! Set a standing date for good times with good people with the plan outlined on page 112, so you'll have something to look forward to each and every month.

5 : **Is there someone in your life who demands more time and attention than you realistically have to spare?**

The infamous time sink takes many forms: that neighbor who drops by without warning, the friend who consults you about her relationship dramas twice a day, the acquaintance who constantly asks for favors, the relative who chats you up for an hour when you just called to say hi. Worst of all, the time sink rarely has time for you when you really need it. Could that giant sucking sound be your time? Quick—turn to page 104.

6 : **When you get invited to do something you'd rather not, what do you say?**

"Maybe" isn't fair to your hosts; "yes" isn't fair to you. Learn to say no gracefully on page 114.

7 : **How many questions do you ask before you say yes to an invite?**

There are five key questions to ask *before* you RSVP. Get all the juicy details on page 116.

8 : **Can you think of a person you've met who intrigues you, and you'd like to get to know better?**

Sometimes destiny needs a nudge. Make time for someone new in your life, as outlined on page 117.

9 : **Flipping through your calendar, do you find any holidays you're not especially looking forward to this year?**

Hey, we're talking about your hard-earned holidays here—if fun isn't on the schedule, that schedule needs revising. Follow the guidelines on page 120 to get a head start on happy holiday memories.

10 : **Think of your ten closest friends: when was the last time you saw each of them in person?**

If you have to think hard about this one, it's time to take action. What kind of action, exactly? Jump to page 108 to find out.

11 : **When was the last time you entertained at home?**

It's probably been awhile, and who can blame you? From the host's perspective, most dinner parties go something like this: hectic preparations, last-minute shower, rounds of introductions, drinks refreshed, plates cleared, dessert served, coats collected, and bleary-eyed goodbyes. But on page 122, you'll discover a much more relaxed, fun way to throw a party—where dinner isn't something you dish out, but something you dish over.

Common Problems—and Solutions

Why do we say we're "only human" when we make mistakes? Being human can be a great gift; it's our natural instinct to devote time to an ailing family member, a friend in need, and complete strangers in times of trouble. But when we bounce from one crisis to the next, we eventually wear ourselves out—and then we're really no good to anyone. This chapter will help you pace yourself for the long haul with your nearest and dearest, find time for a breather to enjoy your own company, and make time for people who inspire and intrigue you. Once you can keep sight of the big picture of your life, you can really enjoy being human. Make your personal time a personal priority!

So many people, so little time . . .

Carpools, meetings, luncheons, play dates, coffee talks, volunteering, professional mixers, birthdays, conferences, cocktails, workouts with friends, babysitting, office parties, fund-raisers, dinner parties, lectures . . . Sometimes when you look over your list of social commitments, your time doesn't seem to belong to you at all. Then, when something comes along that you really want to do—your favorite band's in town for one night only; that hottie at tae kwon do class asks you out—you can't. What a bummer! That's not a social schedule; that's pure drudgery.

You may have been giving your time away before, but today's the day you're going to start valuing it more highly. Imagine that a tropical storm wiped out your social schedule completely, and left you shipwrecked on a desert island with an amazing treasure trove: all the time you want. How would you dream of spending it, and who would you invite to share the treasure of time with you?

- Would you still spend it on all those work functions, or keep volunteering to babysit your sister's tiny terrors two nights a week?

- Would you rather have a hot date at the ballet in that sizzling red dress of yours, take your sister on that trip to Aruba you two always dreamed about, or just catch up with an old friend?

- Wouldn't you like to keep a precious hour or two for yourself to spend at the spa or on a long walk in the woods?

Of course, you'll want to share the wealth with your family, your friends, your neighbors, and your world—but don't go giving it all in one day, or month, or year. Take the tips on the next page to identify your people priorities, set time limits and clear boundaries, and make graceful exits when you hit your limit. Once you do, you'll never have to feel like you're breaking the piggy bank just stealing a few minutes alone or with loved ones.

Examine your people priorities. When everyone else seems to be entitled to your time except you, look over your schedule and ask yourself these crucial questions:

- *Who* on your calendar appreciates the time and effort you're giving them, and who is taking it for granted? Give yourself a break from those who aren't so appreciative of your company, and concentrate on the people who make you feel valued.

- *When* have you set aside time to spend with people who inspire you, and given yourself time to pursue that inspiration? Set up a standing date with a friend who is living her dream, and set aside time—even just an hour a week—to start living yours.

- *Which* appointments do you know from experience are likely to be canceled, rescheduled, or no-shows? If someone keeps forgetting plans with you, canceling on you, or rarely takes the initiative to see you, take a hint and leave that person be for a while. Could be that some urgent matter is taking precedence right now, and your friend will get back to you when possible. Or maybe you just have different priorities, period, in which case it's probably better to part ways.

Assign each interaction a time limit. Before you commit to spending time with someone, calculate how much time you have to spare for that person. Here are some criteria to help you determine whether to commit to two or twenty minutes, two hours or two days:

- *How well do you know this person?* Start with a small time commitment with people you don't know well. If that first scheduled interaction goes well, you can commit to progressively longer dates, until you hit your natural time limit with this particular person. As Jane Austen rightly points out in *Sense and Sensibility:* "Seven years would be insufficient to make some people acquainted with each other, and seven days are more than enough for others."

- *How much do you like this person?* Some people really are best in small doses. You might be pleasantly surprised, of course, but a chat over coffee is a safer bet than a skiing weekend.

- *What else is going on for you that day or week?* Look at your schedule before you commit, even to a friend. If you can foresee that your attention will be divided by an upcoming vacation, work deadline, or helping the kids with Halloween costumes, keep your commitment to a minimum. Explain the situation, and the friend will either appreciate your offer of undivided attention for a few minutes at a busy time for you, or gladly reschedule at a later date.

Set clear boundaries. You may not be able to change other people's habits, but you can adjust yours so that your schedule isn't quite so affected by them.

- *End command performances.* Coming through in a pinch for a family member or friend is admirable—but you don't want to give people the impression that you're at their beck and call. If the same person keeps calling you at the last minute for help, suggest that you can do it at a later date. If that person insists that your help is needed right away, suggest a reasonable substitute. Your aunt who lives an hour away shouldn't expect you to come over and unclog her sink when a neighbor or the plumber could do the job just as well (or better).

- *Make waiting more profitable.* If a friend is regularly fifteen minutes late, adjust your schedule accordingly. Plan to meet in a bookstore, where you can browse for holiday gifts while you wait, and take the subway or bus to your meeting point instead of paying for parking or a cab. It probably won't matter if you're a couple of minutes late, and you can always call to alert the person if public transportation is running behind schedule.

- *Don't get hung up on no-shows.* Wait twenty minutes past the appointed time, and then call to see what's keeping your date. If no one picks up, leave a message; then take off and continue your day. Look on the bright side: you've just scored some bonus downtime or a head start on the next item on your schedule. If the person has a good reason for not showing and wants to reschedule, make sure it's convenient for you. You might suggest a meeting point that's near your home or office, or even ask the person if you could combine your meeting with some light task, such as shopping for holiday cards or baking cookies for a fund-raiser. That way, both your friendship and your schedule remain intact!

Quit while you're ahead. Wear a watch to your social engagements so that you don't overstay your welcome, and stick to your own time limits. This goes for events with people you enjoy, as well as ones you're not sure you're going to enjoy. We tend to let so-so social interactions drag on in the hopes that they'll get better, and we prolong pleasant ones in the expectation that they'll continue to be fun. Either way, you'll end up putting pressure on your schedule and wearing yourself out. Here are some strategies for a graceful exit:

- *Mind the time.* Sneak a peek at the clock on the wall or your watch (in the restroom, so it's not so obvious) so that you're not late for your next event or sleep-deprived tomorrow. If it's 10 p.m. at a dinner party and the entrée still hasn't been served, offer to help your host clear the soup and salad dishes. If you have an early morning, mention it to your host on your way into the kitchen. Your host might take a hint and speed things along or at the very least won't be caught off guard when you duck out before coffee is served. This is much more polite than an abrupt "Look at the time! I have to get going . . ." just as the host is bringing out a fancy dessert soufflé that took all day to make.

- *If your attention wanders, follow it.* If you feign interest in limited-edition coins beyond a polite inquiry or two, the coin collectors in the crowd are either going to talk your ear off

about it or notice that you are faking and feel patronized. Better to excuse yourself to freshen up your drink, help out your host, or head for the restroom. And if you should happen to catch the eye of an intriguing stranger over by the hors d'oeuvres, now might be a good time to wrap up the small talk so you can go introduce yourself.

• *Bring someone else into the conversation.* If conversation with a particular person tapers off and begins to seem awkward or forced, try introducing someone who might make it interesting. This way the pressure's off you, and you can bow out of the conversation more easily. If you don't want to strand a friend with an incompatible conversation partner, just grab your friend by the arm and say, "There's someone else I was meaning to introduce you to . . ." or "You have to try the crab cakes . . ." Then turn to the third party and say, "Will you excuse us?" That person might be just as relieved as you are to escape an awkward scenario.

• *Listen to your body.* If your eyelids are drooping and you feel a yawn coming on, don't try to prop yourself up and follow a conversation. You might not succeed—and the biggest social gaffe of all is to fall asleep while someone is talking to you. Instead, excuse yourself politely with an interjection along these lines: "I wish I were more alert right now, because I'm interested in what you're saying, but I'm afraid the week is catching up with me, and I need to head home. Maybe we can pick this up another time?"

tip	**Feel free to move on.** If you're not having fun where you are, or some guy is making unwelcome advances on your friend, or the wait is taking too long and stomachs are growling, suggest a change of venue. And if you suddenly hit a wall where you're too tired, have had a bit much to eat or drink, or just want the comfort of your own bed, go home. This is a social event, not a sporting event, so you're not going to lose points for early elimination. Quit while you're still having fun.
tip	**Stay in the safe zone with new acquaintances.** With people you don't know particularly well or just aren't that close to, you can always enjoy these short and sweet interactions:

- Share common interests, such as gardening or jogging.
- Chat about movies, books, TV, art, sports, travel, or vacations.
- Collaborate on group projects, such as a block party or crafts.
- Catch up on news of mutual friends.

Problem:

I never get to see my friends anymore.

Sounds like you've got your priorities straight. Social connections are our main strategy for survival as human beings; we wouldn't have made it all these millennia without a real knack for this whole friendship thing. We all have a deep need for community beyond our families and workplaces, and you'll have that much more to offer both work and family when this need is filled.

So now that you know who you want to spend time with, the obvious next step is to free up time to make that happen. First, we'll take a look at your schedule. Whose names appear there, and who are these people who are taking up all your time? If people you're not especially close to have taken over your schedule, consider scaling back those engagements, as outlined on the next page.

Next, track your social interactions over the course of a day. You'll notice some of the most time-consuming social interactions are not scheduled at all but happen when you bump into a neighbor taking out the garbage or get waylaid by a phone call from a chatty acquaintance from your garden club. Then there are the scheduled social commitments that take longer than you might have expected, or leave you feeling drained. Take the hints on the next page to keep interactions short, and make them that much sweeter.

Once you've taken charge of your social schedule, you'll find that you finally have time to make that call to catch up with a friend or two, and set up a standing once-a-month date for lunch or dinner. Friends are the ultimate organizing aid: just knowing you'll see them soon will help keep you calm, content, and on task all month long.

The Personal Organizing Workbook

tip	

Pace yourself.

New in town, recently single, or kids off to college? You may be tempted to load up your social schedule just to fill the time suddenly available to you. But before you start discounting your time in bulk like pretzels at Costco, keep these pointers in mind:

• Your time is as valuable now as it ever has been—maybe even more so. Now you actually have time to figure out what you want to do, and time to start doing it, too!

• Give yourself some time to get to know people before you start making major plans with them, like going away for the weekend or throwing a big party together. Most relationships take a while to unfold, and that's just fine. What's the big hurry?

• Don't let new friends completely dominate your social schedule. You don't want to invest so much in new relationships that you neglect old ones, or start spreading yourself so thin that you don't really get to know anyone.

Organizing Solutions:

Cut back on repeat engagements. If you see the same name pop up on your schedule multiple times this month and that person is not one of your dearest friends, consider taking the following actions:

• *Combine commitments.* Instead of meeting twice to discuss a fund-raising event, see if the agendas for the two meetings can be combined into one highly productive meeting.

• *Cancel one of two engagements with the same person.* If you're going to see your old boss at a conference next week anyway, she might not be so devastated if you canceled your plans for cocktails this week.

• *Minimize the time involved.* Maybe instead of meeting over lunch, when people are distracted by the food in front of them, you could reschedule a meeting over coffee or right after work, when people will be eager to finish up and get home for dinner.

• *Find a substitute.* If you agreed to help organize a book club without realizing how much time it would entail, find an enthusiastic individual (or two) who might be willing to take your place. Wrap up any outstanding work so that it will be easy for that person to pick up where you leave off. Then explain the situation honestly and gently to your fellow planners, accepting full responsibility for your actions. "I'm so sorry. I underestimated the time involved, and I just don't have time to do the job as it should be done. But I know an avid book lover who'd be willing to host the book club this month, and I can give you all her contact info . . ."

Keep unscheduled interactions brief and productive. Here are the do's and don'ts:

• *Do* suggest scheduling a time to talk when interrupted. The other person will be more appreciative and respectful of your time, and may even take the initiative to solve that problem that supposedly required your immediate attention. If you know the conversation will be difficult, choose when you're usually at your best—say, Sunday morning, or Wednesday after yoga class. It's your schedule, and you're sticking to it!

• *Do* disconnect from phone and e-mail, and connect with the person in front of you. The constant interruptions of a ringing phone or pinging e-mail are counterproductive. Turn them off, or at least warn the other person if you're expecting an important call and may have to excuse yourself. You won't be so distracted when you're having a conversation, and you'll make the other person feel that much more cared for and valued. If your appointment lasts several hours, set times that you will check messages so that you don't wind up checking obsessively, or avoiding them altogether.

• *Do* make your time constraints clear from the outset. If your schedule is packed, tell everyone who approaches you that you only have a limited time to talk. That way, they'll get the benefit of your complete and undivided attention for a

few precious minutes, and you'll get them to cut to the chase much faster. If the conversation is helpful or enjoyable, you can always ask to extend the conversation. Try something along these lines: "I'm really interested in what you're saying, and I think I can push the other items on my agenda back ten or fifteen minutes if you want to talk more over coffee . . ."

• *Don't* get trapped in a touchy conversation. There are five topics that are difficult to discuss even in the best of circumstances: religion, sex, parenting, politics, and money. So if you're pressed for time, do yourself and everyone else a favor and avoid these touchy subjects . . . even in jest. If there's a difference of opinion in the room, it's liable to touch off a firestorm of controversy. If someone you're not especially close to broaches the subject, laugh it off: "Why do you want to know if I'm a Democrat or a Republican? You running for office?"

• *Don't* try to handle anything after 10 p.m. The American Insomnia Association cites relationship concerns as a key trigger for insomnia—making us clumsy, cranky, and ineffective for days after, until we finally catch up on our Z's. Besides, ninety-nine times out of one hundred, it can wait until tomorrow morning. So if you do get a late-night phone call from a weepy friend about a breakup, listen as best you can to get the basic facts, express your heartfelt sympathy, and then ask if you can talk first thing tomorrow. It's clinically proven: you'll be calmer, sharper, and more sympathetic in the morning.

Schedule a standing date with friends. To be sure you get to touch base with friends at least once a month, find a date that generally works for one or more friends. It doesn't have to be fancy; as long as you're among friends, it'll be special. Meet up for brunch at a favorite diner, host teatime at your place, or make it a rotating dinner party so that you each get to enjoy a free home-cooked meal. As the date approaches:

• *Send out an e-mail RSVP* and reminder to all invitees.

• *Pool resources* so there's no undue financial or time pressure on any one person. You might all take turns being the sous chef for a dinner party, for example, or chip in a bottle each for your wine-tasting night.

• *Confirm each guest's contribution in advance.* Otherwise, you might end up with an all chips-and-dip potluck. Provide a cost estimate with any invite to dine out at a restaurant, and you'll avoid that awkward moment when the bill comes and one person is shocked at the price of her share.

I hate to turn down an invitation, but my social schedule is wearing me out!

Say it with me now: "I'm sorry. I can't make it." That wasn't so hard, was it? Much easier than trying to hit a birthday party, an art opening, and a baby shower all in the same two-hour time span. In fact, it might even be a relief, especially if it's your boss's birthday party, your ex's art opening, and a combo baby shower and circumcision. Besides, your hosts would probably rather see you another time than catch you in the midst of a mad dash from one engagement to the next.

But what happens if you say no and your host sounds disappointed, or a fellow guest offers a lift to make it easier for you attend? Which of the following do you say next?

1. "Well, I *might* be able to make it . . ."
2. "*Cough* . . . I'm not feeling so well *(cough, cough)*."
3. "Who else is going to be there?"
4. "Can I let you know Friday afternoon if I can make it that night?"
5. "You must think I'm such a jerk. How can I ever make it up to you? Please don't hate me . . ."
6. "Will there be any other singles there?"
7. "OK, but only for, like, twenty minutes."
8. "Maybe I could cancel on those other people. I never really liked them anyway."
9. "Is it a no-host bar?"
10. "I'm sorry. I just can't make it."

There's only one appropriate answer here, and it doesn't involve an open bar, dating prospects, cattiness, groveling, or a prima donna attitude. "Maybe" is not a real answer, and pretty much all the other responses are guaranteed to get you permanently removed from the host's invite list. Be gentle, but firm—and honest! Fake excuses will have you looking over your shoulder, afraid your friend will discover you out at the movies when you pretended to be bedridden. If you do have a reason you can't make it that you care to share, make it quick; all your host really needs is a simple yes or no.

The Personal Organizing Workbook

If you're tempted to say "yes" or "maybe" when your schedule says "no," ask yourself this: why do you feel the need to be so overextended? The people who really care about you won't forget about you if you cut back your lunch dates to once a week, or stop admiring you if you take on one fewer volunteer commitment. Other people are either going to be impressed with who you are and what you're all about, or not; there's only so much you can do. Say "no" kindly but firmly, and no one will hold it against you; say "yes" decisively and enthusiastically, and your host will be thrilled.

| tip |

Don't take a rain check unless you really want one.

If you agree to do lunch and then don't, you'll look like either a flake or a fake. You don't owe the person who invited you anything, really; you didn't ask to be invited. If the host isn't someone you really know or like, it's better not to string that person along—and maybe he or she was only inviting you to be polite anyway.

| tip |

When you say yes, make it count.

Setting priorities and sticking to them isn't just an admirable character trait—it's the key to making friends, and keeping them, too. You might say no and think better of it at the last minute, but then what kind of message would you be sending your friend? "Turns out I had nothing better to do, so here I am!" When you say yes to a friend, you should be decisive about it—it's a clear sign of your devotion and loyalty. If you say yes and bail out at the last minute, your pal might decide to invite a more reliable friend next time. Besides, once you really commit to an event, you'll begin to get psyched up for it. Anticipation can be the most fun part of a date!

Organizing Solutions:

Get the details *before* you RSVP. There are five key questions you need to ask before you say yes or no:

1. Where will it be held? Before you agree to cohost a bridal shower, you might want to find out if the family is expecting it to be held in the bride's hometown in Bangladesh.

2. When exactly will it take place? Is it the same day your sister's baby is due, or right before your bar exam? When scheduling, be sure to factor in the time it will take you to get there and back, too. Heading downtown means finding a parking space; heading across the country means asking your boss for time off.

3. What's on the agenda? What role will you be expected to play? Does participating in a fund-raiser commit you to raising a minimum amount? If you accompany your friend to his support group, will you be expected to stand up and talk about your childhood?

4. How much will it cost? If paying a month's rent for a bridesmaid's gown just isn't in your budget, you may need to think twice.

5. What about guests? Are you allowed to bring your family, or expected to bring a date? Get the lowdown, and remember: never commit on anyone else's behalf without consulting that person first.

Know your limits. Never say yes right away to an invitation; always take the time to consider your

- *Priorities.* Spending quality time with your significant other when you've been out of town for work might take precedence over a company softball game; so be it.

- *Health.* Scheduling two barbecues on the same day could be a recipe for indigestion, not to mention wreaking havoc with a diet.

- *Safety.* If attending two events back-to-back means a mad dash across town, ask your second host if you can arrive late. Sure beats a speeding ticket or a dented fender.

- *Cash flow.* If your budget is tight, now might not be the best time to go shopping or to a fancy restaurant with a high-rolling friend. Suggest a fun, lower-rent alternative—a spring-time walk in the park or an at-home horror-movie festival complete with popcorn with blood-red food coloring—or reschedule for sometime after payday.

- *Rest.* Always have cab fare home in case the person you arrived at an event with wants to stay out late and you don't. Unless you're a serious party animal, don't agree to meet up with friends for drinks two nights in a row—especially on a work night. If you're a new mom, remember: you have license to cancel on anyone, anytime for a nap, no questions asked.

Pursue Someone New

Time required: ¹/₂ hour–1 hour

How many times have you had a fascinating conversation that ended with "We have to continue this another time!" or "Let's do lunch" only to let days, then weeks, then months pass without following up? Making new friends takes time, and that means going out on a limb to extend an invitation, make time available, show your interest, and follow through on positive interactions. Now that you're organized, this will be that much easier—so take a chance, and make a connection!

1 **Make it a date.** "Let's have coffee . . . sometime" isn't exactly the strongest start to a friendship. If you take a risk and ask to set up a date, the other person is likely to reciprocate. Ask what days of the week and times of day are usually best for the other person, then suggest a date and time within those guidelines in the next few weeks that works for you, too. If at first you don't succeed, don't be shy about trying again—the other person will be flattered by your persistence!

2 **Make it clear that you have no ulterior motive.** Instead of leaving your new neighbor guessing why you're inviting him to lunch, explain that you just like to get to know your neighbors a little. You don't want him to think you're being nosy, angling for someone to fix your leaky roof for free, or trolling for a date. Offer a few options, but leave the final choice of time and place up to him to decide—that way, you'll come across as enthusiastic and flexible, not overbearing. If he suggests after-dinner drinks at his place, you can always counteroffer with afternoon coffee in a busy downtown cafe to make sure he's not getting the wrong message.

Continued →

3 **Show a genuine interest.** Once you're through the basic pleasantries, try not to let the conversation revolve around you. Start asking questions to find out what this person is really all about. If you're not getting anywhere with the usual questions (What do you do? Where do you live? Where are you from? How do you know so-and-so?) you might try a few more penetrating ice breakers, such as:

- What's one thing you'd like me to know about you right away?

- What is your favorite dish? Why?

- How do people who know you well usually describe you to people who don't?

- What are you looking forward to most this weekend?

- What is it about you that people might not guess just by looking at you?

If your guest initially seems reluctant to share, you might divulge a personal detail or anecdote yourself just to put her or him at ease. If one or two questions don't take, don't worry—just keep asking until you find a subject that sparks your guest's interests. Then you might not get your newfound pal to *stop* talking!

4 **Seek common ground.** If you have a friend in common, that's a good start. Talk about what you enjoy about that person, or share an anecdote that involves that person. But don't stop there: try to probe for other passions, ideas, and interests you might share. If you don't agree with what you hear, fine, but try not to be too quick to judge. Responding to someone who claims to be a die-hard wrestling fan with "But professional wrestling is totally fake!" is more likely to get you in a headlock than in anyone's good graces. Instead, take the opportunity to find out more: "What do you like most about it? Did you ever wrestle yourself?" Who knows? You might find out that you both get a kick out of watching sumo wrestling championships on TV or had similar experiences on high school sports teams. If you sense a major disagreement coming, you might want to gently steer the conversation in another direction. Every relationship comes with its differences—but before you go through the trouble of working those out, first establish whether you actually want to have a relationship with this person.

5 **Ask for advice,** and you can instantly turn strangers into allies. As soon as they weigh in with an opinion of what you should do, they stop being impartial observers of your life; now they've got a personal interest in how it all turns out for you. Besides, everyone likes to feel like an expert about something. So if you have no obvious interests in common with your brother's new girlfriend the insurance risk assessor (besides your brother), think of what expertise you might tap. "What do you think my brother would like for his birthday?" "How dangerous would it really be for me to get a motorcycle?" "What are the odds that the cord would snap if I went bungee jumping on vacation?"

6 **Leave on a high note.** If your half-hour coffee date flies by because you're both having a good time, say, "This was fun. Can we do it again sometime?" You don't want to overextend your welcome or discover a reason *not* to like this person.

7 **Break the ice—not once, but twice.** If you had a good time, why wait for the other person to call? This is friendship, not dating, and there are no rules! And if it didn't go quite as well as you planned, you might want to try again. If you didn't exactly hit it off with one of the bridesmaids at your friend's wedding shower, things could turn around for you before the wedding if you give it a chance. So go ahead and suggest a chat over coffee or lunch. Odds are, she'll be so surprised, flattered, or curious (or all three!) by you making the effort that she'll take you up on it. First impressions are just a starting point—your friendship can move onward and upward from there!

tip

Build on your positive interaction.

A thank-you e-mail or card is always nice. But you could also keep the connection alive by saying a warm hello when you see each other, sending your regards through a mutual friend, following up on something you talked about ("Hey Fran—how's the scuba certification going?"), remarking on positive changes ("Those dahlias are looking great, David!"), and extending invitations to social events.

Add Fun to Your Holiday Plans

Time required: 1–3 hours

What with all the errands, cleaning, cooking, shopping, and coordinating involved, sometimes a holiday can begin to look suspiciously like work. Consider the next holiday on your calendar your chance to make a break from the grind instead of adding to the pressures of daily life. Switch things up with a change of venue, some fresh faces, and a relaxed schedule, and you won't need a vacation after your vacation!

1

Opt for a change of venue. Why settle into the same chairs around the same table as last year? Mix things up:

- *Choose a dream destination.* Instead of heading home for the holidays, why not Hawaii or Kenya? That's one sure way to break out of a holiday rut! Hop online and check out your options.

- *Close for the holidays.* If you'd like a break from hosting, all you need to do is say so. Make the call or send an e-mail announcement to let your favorite holiday guests know that you'd love to see them but you won't be hosting this year. This will give someone else in your crowd a chance to step up and offer to host the festivities. So what if everyone wants to celebrate, and no one wants to host? Well, that's what restaurants are for . . . and there's no time like the present to make reservations.

- *Get the home-turf advantage.* If you always have Thanksgiving at your sister's place six hours away, why not have it on your own turf for a change? Not only would this save you travel time, it would give you control over the guest list and menu, too. Then you could invite friends along, and you don't have to choke down your sister's "famous" gelatin salad with cream cheese, raisins, and celery. Give your sister a call, and let her know you'd like to host.

2 **Revise the guest list.** Spending time with a few people you truly enjoy is a great way to celebrate—but entertaining your entire extended family or circle of acquaintances (or both) becomes an exercise in project management. Picture that checklist: "Prepare dinner for fifty; stock bar and wine cellar for all-day event; buy small presents so no one feels left out of gift giving; plan something for the kids to do; make sure crazy Uncle Manny doesn't drink too much and start cracking inappropriate jokes . . ." Now, compare that to a checklist for a holiday party with a few close friends and a favorite cousin: "Get cousin Reid to bring mulled wine; buy cookie dough and sprinkles; fire up iPod; decorate cookies to heart's content with my favorite people in the world." See that? There's no one to impress, and so much more to enjoy. So sit down and make a small guest list consisting entirely of people you're close to—bet it's a snap.

3 **Schedule in downtime.** The best holidays aren't hectic; they're the ones where you have time to enjoy a heart-to-heart with an old friend, catch up with your favorite aunt, or play hide-and-seek with your nephews. You might schedule a couple of planned activities so that everyone has a chance to touch base, but leave the rest open so that people have a chance to tell stories, admire gifts, linger over dinner, show off their best party tricks, and take part in some spontaneous fun. If you do plan a feast or another big event as part of the festivities, be sure to schedule yourself a time-out in the midst of it all. You'll be able to step outside for a breath of fresh air and enjoy a private moment of triumph and gratitude for this wonderful holiday.

Entertain Friends . . . and Yourself!

Time required: 3–4 hours

Who says that a good time requires the perfect place setting, fifty people, or a ten-course feast? Instead of exploring the outer limits of your hospitality, make your next little get-together just that: a little get-together. Pool resources and talents so that everyone at the party gets to have fun, and show off a little bit, too. Compliments and cocktails all around!

1 **Plan fun to be had by all.** Tailor your guest list to your chosen activity or your activity to your chosen guest list. If you're determined to go to the new musical all the critics are raving about, don't try dragging along friends who are allergic to show tunes. You don't want the guilt of enjoying yourself while an anti-musical friend is wincing through every song and dance routine. Either change your guest list or find an activity everyone on it can enjoy—say, karaoke.

2 **Invite only who you like.** If you want to invite Michael, do you have to invite his obnoxious little brother who just moved to town, too? What about that new boyfriend of Linda's who she drags everywhere with her like a teddy bear? Is it OK to invite Alyson even though she's on the outs with Katie? What about your friends' kids—can they come too? With questions like these, a simple guest list can begin to sound like an SAT question. Quit worrying, and trust that since they're all adults, they can appreciate the meaning of "just a few really close friends" and "by invitation only," and can all manage to get along just fine for one night. You can invite these other people along some other time, maybe, but tonight is your night for some serious bonding for a change. Unless you're hosting a pity party, your guests should be people you *can't wait* to see, not people you *have* to see.

3 **Keep the meal simple.** Since your house isn't a Zagat-rated restaurant, no one expects a five-course meal. Besides, anything you provide will be appreciated by your friends. So:

> • *Scale down your grand plans.* If you have visions of a summer barbecue but haven't actually logged that much grill time, don't stress yourself out trying to learn before the big event. Your friends would probably be just as happy with some fruity drinks by the pool, and you wouldn't have to spend all afternoon by the grill. And instead of putting pressure on yourself to produce a fancy entrée, you can make a meal entirely of tapas, or small dishes.

> • *Strip down to the basics.* Complete your menu—then either subtract one item, or opt for a simpler version of those menu items. Who needs complicated cocktails and over-the-top hors d'oeuvres? Go with wine and cheese instead. If you want to make it unusual, pair cheese and wine from a particular part of the world—say, California or South Africa—as long as you don't go searching every store in town for it.

> • *Don't bother with a menu at all.* Who can be expected to keep track of who's on a diet, vegan, avoiding carbs, or allergic to seafood anymore? Let your guests choose their menu for themselves! Assemble various sushi makings, different toppings for pizza, or several sauces for a pasta bar. Your guests can take it from there. They'll be so grateful that you accommodated their dietary needs, and you can honestly say it was no trouble at all.

4 **Delegate.** Your nearest and dearest don't expect you to suddenly morph into a five-star chef, master floral arranger, superfly DJ, expert sommelier, and one-person home-design team. So why expect that of yourself? If there's one thing you especially enjoy doing, concentrate on that. As for the others . . .

> • *Make use of in-house talent.* Take ten minutes to look over your guest list. What talents can they bring to the table? Your hip pal Adeline who sings with a salsa band would probably be happy to supply a fun party mix, and you could convince Marissa the wine aficionado to help you pick out a few cases of great wines at good prices. Anthony just took that ikebana class; maybe he'd be willing to provide the flower arrangement? Call and extend

Continued →

those special guest-star invitations now, and your humble get-together will be anything but. Is it hot in here, or is it just you and your fabulous party?! Be sure to share the love and the credit where they're due: acknowledge the contributions of your talented guests, possibly on the invitation and definitely with a toast at the party. Next time, it won't take much convincing to get your guests to help again.

• **Prep with pals.** Party prep is always much more fun and creative when you don't wait until the last minute. Spend an hour or so with some friends to prepare some easy canapés or dollops of cookie dough and freeze them, so all you have to do is pop them in the oven before your party. And who says party planning has to be all work and no play? Making decorations could be a fun craft project to do with your friends the weekend before your big event. The next time you and your friends rock out to a fun song when you're in the car or working out together, make a note to add it to your party playlist.

• **Hire help.** Here's a party planner's trade secret: the host with the most is the host with the most help. Hire a chef to prepare the entrée, buy precut fruit platters, pay a bartender to mix cocktails, get the neighbor's teenager to bake his famous pies for the occasion, and pay your friend's college kid to DJ. In a few minutes of phone calls, the whole party is a done deal, no party planner required. Now all you have to do is show up, and have fun!

5 **Make another date.** This will give you more to look forward to, and make good-byes so much easier. Plant the seed now, and your social life will continue to flourish.

tip

To break up the routine, choose a theme.

Imagine what your next get-together might be—maybe Pool Shark Night, an All Blue Evening, or April in Paris? The point is for you to have fun, not to end up moonlighting as the ringmaster of your own circus, so choose a theme that doesn't require too much effort on your part. If you already have the bulk animal crackers and sequined top hat for Big Top Tuesday, then step right up to the greatest show in town!

STAY *organized*

You've worked wonders all by yourself, with a boost from this book. Your space has been beautifully organized, you can find everything, and, at last, all your stuff has found a home in your home. You've conquered your to-do list, and created room in your schedule for fun and friends. You've left yourself plenty of time to send out invitations, plan the menu, clean the house, and cook the meal—and then it hits.

All of a sudden, your desk is piled with recipe printouts, the kitchen is cluttered with food, and there are dishes everywhere. The scheduled time approaches, and the guests still haven't arrived—and that's when it occurs to you that you forgot to send out a reminder with directions. What *happened?!* You thought you'd come so far with your newfound organizational skills . . . how did you wind up back at square one?

Easy there, tiger. You *have* come a long way, and momentary panic isn't going to change that. The impressive fact of the matter is that now you actually *know* the difference between a frantic fiesta and an easygoing, well-organized event that's a good time had by all. Consider this one part of your learning experience and laugh off any goofs, confident that the next one can and will be better.

With any steep learning curve, there's bound to be a little backsliding—but this chapter will help you get back on top of your world. Stuff piling up on you? We'll replace old accumulating habits that don't work so well for you anymore with easy routines to keep stuff in check, and make your life that much simpler and more stress free. Tasks running into overtime? A few key tips on effective record keeping will help you delegate more and forget less, so that you have more time to savor your successes, and move on to bigger and better things. Caught in a whirlwind of social obligations that aren't really much fun? Try making no commitments at all for a change, and rebuild your social calendar from there—one personal priority at a time.

So once you're organized, what's next? Now there's an intriguing question. The reward for being organized is not just free time; it's the time to live your dreams. Since you've worked through the first three chapters, you've already made the leap. Now all that's left is to stand your ground, and enjoy the view.

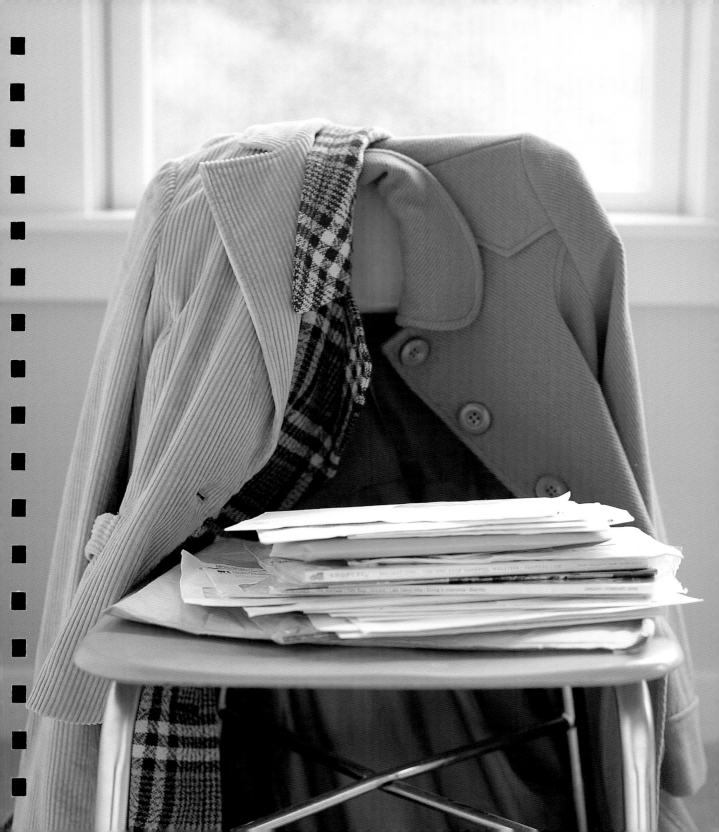

questionnaire

* * *

1 : **Do you find that old habits—stockpiling stuff, lateness, overcommitting—die hard?**

Well, maybe that's because they do. Instead of trying to quit old habits, try replacing them with the new, improved ones described on page 137.

2 : **Do you start the week with your stuff, your schedule, and your personal priorities firmly in place but find that things seem to be slipping out of control again by midweek?**

Hey, don't we all! Life has a way of thwarting our best intentions. But with some relatively minor, routine maintenance, you can avoid that seemingly inevitable midweek slump. Find out how on page 137.

3 : **Are you taking care of minor concerns, but major ones are still slipping through the cracks?**

The real question here is, what cracks? The ones in the notebook that you've been writing these things down in religiously or the ones in your sleek digital voice recorder with space for ten hours of voice notes? Ah, you see my point. Give your record keeping a boost with the helpful hints on page 140.

The Personal Organizing Workbook

4 : **Are you finding that more often than not, tasks you delegate aren't getting done?**

Other people have memory lapses too . . . but that doesn't mean you have to pick up their slack. Page 144 describes how to improve your follow-up, and improve your results—without adding to your own workload.

5 : **Are you still hard-pressed to find even twenty minutes of personal time each day?**

Actually, you're off to a good start: at least "personal time" is in your vocabulary and part of your day. Now you can start expanding and making the most of that time, using the tips on page 147.

6 : **Take a look at your weekend plans: do they make you feel excited or overwhelmed?**

Weekends are supposed to be down-time, remember? Learn how to tell what's worth your time and what isn't *before* you set aside time, pick out the outfit, and buy the tickets, using the guidelines on page 147.

7 : **In the course of your busy day, do you tend to lose track of the bright ideas that occur to you or the helpful tips you hear?**

If there's one idea I hope you've gained from this book, it's this: the smallest spark could be all you need to change your life, and change the world with you. So please, do us all a favor, and don't let those inspirations go to waste! Use the tips on page 150, and start seizing the day, every day.

8 : **When Friday rolls around, do you ever wonder where your week went?**

Even the best-laid plans on Monday can sometimes go awry by Friday—but plans that are never firmed up Monday are usually doomed by Tuesday. Get your week back on track with the suggestions on page 152.

9 : **When the New Year rolls around, do you ever wonder where your year went?**

Weeks may be slippery, but they're not nearly as slippery as years. They can slide right through your fingers before you ever get a chance to take that dream vacation, explore your creative side, or live up to your potential. But now that you are organized, you have a firmer grasp than ever on the year ahead. Who needs New Year's resolutions to make a dream come true? Not you—with some help from the exercise on page 154, you'll have yourself a *plan*.

Common Problems—and Solutions

Spontaneity is the spice of life—but what good is spice without something to sprinkle it on? Organization provides you with the essential confidence and capability to savor unexpected delights, and keep all the ingredients of life in balance, so there's no bitter aftertaste. Since you've come this far in the book, you already know how much sweeter life can be with less stuff, less stress, and more joy. Your challenge from this point on is just to keep on living your success, and never again settle for a day that is less than delicious.

tip

Ease into new habits.

Any lifestyle change takes concentration, and that can add to your stress levels. So during that first month, set yourself up for an easy transition:

- Avoid major shopping; you'll despair trying to find places to put the new things.

- Don't plan a major event at your house, so you can avoid stuffing everything into closets before the guests arrive.

- After the first month, ease back into your usual routine, with the one improvement that you've made.

I can't seem to shake old habits.

Give yourself time. As I always warn new clients, you have to maintain your new habit for at least a month before you start to get the feel of it. Changing old habits is not an easy process psychologically, and backsliding happens so easily. Here's how it usually occurs:

- *Stress causes a hiccup in your system.* You're exhausted at work and can't deal with the new project that suddenly lands on your desk, or a bunch of bills arrive at a time when money is tight and you feel too overwhelmed to sort them all out.

- *Shame sets in over what happened.* You feel bad that you're not exactly following your system to the letter, but solving the problem would be like admitting failure—so instead you hide the problem, put off dealing with it, or let it slide even further.

- *The problem cascades.* Instead of putting a box away where it belongs, you shove it in the closet— and before you know it, the closet is overflowing with things that don't belong there. Since there's no longer any room in the closet for your coat, you hang it on the back of a chair. Once the chair is covered with coats, you're not going to sit on it, so you pile some mail on the seat. Then the pile grows, the bills are buried, and your finances get behind. One thing leads to another, and the system collapses under the mighty mess.

The trick is to try to catch yourself early in this process. The best warning sign that something is amiss is that some *thing* is amiss: what is that box doing in the closet? When you see a trouble spot like this, don't feel bad about it—fix it. Stress can and will cause goofs, but the key is not letting yourself be paralyzed by shame over it. Instead, congratulate yourself on recognizing the problem, and fix it before it cascades. The tips on the next page should help you get back on track in no time.

Prevent pileup. How many times have you taken hours or days to sort through and stash a pile of stuff, and before you know it, the pile is back? Overflowing stuff is usually the first sign that disorganization is creeping back into your life—but don't give up on all that hard-won organization you've achieved! Just ask yourself these key questions:

When is the last time I got rid of something I haven't been using? Try and get in the habit to do this at least once a month. Freeing up space actually helps free up your mind, too, so you can concentrate on something other than keeping your stuff in check.

When I come home from a shopping trip with half a dozen new things, how many things do I get rid of? An equivalent number would be ideal; three would be impressive; one or two a good start; and none means there's plenty of room for improvement. If you know you like to hang on to things, start at the low end of the scale and work upward from there.

How often do I buy things that aren't on my shopping list because they were a good deal or on sale? Bargain shopping is fun—but when you bring home more than one bargain per week, all those deals begin to pile up on you. Even the sweetest deal can turn sour if it's never used, gets in your way, slows you down, or irritates you because there's no place for it. If your closets have hit maximum capacity and your basement is already full of bargains, cut down on the number of shopping trips you make every week . . . and, yes, this includes online shopping too! If you do have to go to the store or order something, make sure you bring a list with you, and stick to it religiously. If a tempting item is not on the list, you can add it to your list for next time—and by then, you probably won't even want it anymore.

Do I make room for an item before I buy it or afterward? If you haven't cleared out a space for an item on your list and can't immediately picture where you're going to put it, just put it down and walk away. You'll never have to deal with those piles on the counter or bags in the hall again.

Give yourself a habit makeover. Habits may be hard to change, but they're actually not that hard to *tweak* just a little bit—and that may be all the change you need. Here are just a few examples of how you might tweak your habits to suit your new, organized lifestyle:

Instead of: When I take off my clothes at the end of the day, they usually wind up on the floor while I hunt for my PJs—and that's where they tend to stay.

Try: When I take off my clothes at the end of the day, I'm in my walk-in closet, so it's easy to put them away and find my PJs.

Instead of: When someone gives me a gift, I hold on to it even though I might not like it.

continued

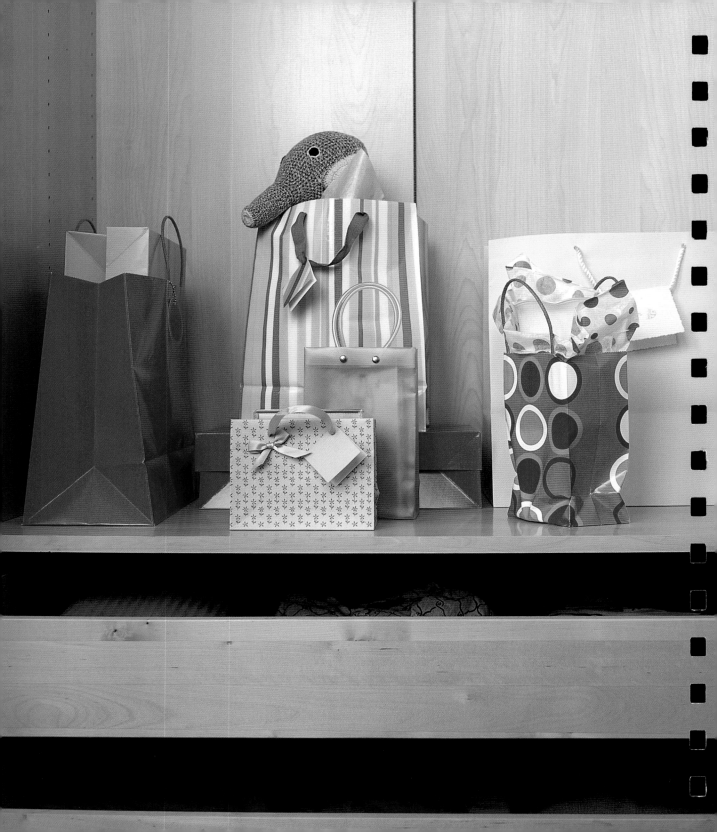

Try: When someone gives me a gift I'm not crazy about, I keep the gift tag or card with it, then I put it directly in my designated gift closet or cabinet, where it will be regifted. (Since the tag is with it, you won't have to worry that you might give it back to the person who gave it to you or her sister.)

• *Instead of:* When I notice I've missed a call on my cell, I check voice mail and jot the message down on whatever's handy. Then, once I've returned the call, I toss the paper.

Try: When I notice I've missed a call on my cell, I look at the phone number and see if it's a call I'm expecting. If not, I finish whatever it is I'm doing first. If it is, I wait for an opportune moment to excuse myself. Then I pull out my schedule and check voice mail, making a note in my schedule with all the necessary details. If no one answers when I return the call, I make a note to check back later.

Don't lose sight of the big picture. Instead of fixating on today's problems, think about what you can do today to get to a better place tomorrow. Here's how that works:

• *Forget past shortcomings;* be enthusiastic about what you can do today. If your accounting begins to fill up your desk, set aside time to handle one small part of it today, such as going through your receipts for the day or the week. This much you can do, right? Go to it!

• *Write down your top priorities in life,* make a list of things you want to accomplish in each of these areas, and visualize yourself achieving these goals. How does the problem you're facing today fit into that picture? If financial success is one of those goals, making a dent in your accounting is a step in the right direction. Spending quality time with friends is a priority? All the more reason to get your accounting done quickly, so you can call up a friend later and see what's doing.

• *Take good care of yourself* so that you can fully enjoy your successes when (not if!) you achieve them. Don't lose sleep over that accounting, or forgo dinner with the family just to get it done. Do what you can, but don't lose sight of your own needs in the process.

What was it I was supposed to do, again?

This thought occurs at the most inconvenient times: you're in the frozen foods aisle, and you can't remember for the life of you what you needed. Or maybe you're in the car turning right at the post office, and you suddenly wonder whether you're doing it out of habit or because you actually had an errand to run on this side of town. Maddening, isn't it?

No matter how hard you try to memorize your to-do list, memory lapses are bound to happen . . . especially when you're stressed out or trying to remember many things. Most of us quickly shrug off memory lapses and say, "If it were really important, I'd remember it." Actually, the human brain has a habit of suppressing difficult or stress-inducing thoughts—and since some of the most important items on your to-do list may also be the most difficult or pressing, you could very well forget them. Case in point: we all know taxes are always due the same time each year, but somehow our minds can conveniently forget that we have to complete all those mounds of paperwork. So much for mental notes!

Instead of counting on the quirky human brain, trust your most crucial tasks to paper or a handheld organizer. With the tips on the next page, you won't forget those promises you made in passing to call a friend or take out the garbage. When your tasks begin to add up, don't panic: group like tasks together into three categories, and you're more likely to remember them all without even looking. Want to be extra-sure you don't let an important date slip? Make your intentions a matter of public record, and you're much more likely to remember—we tend to be more accountable to others than we are to ourselves.

Once you take these precautions, you don't actually need to remember anything . . . except to consult your calendar regularly. Blanking out is not a problem when you can fill in those blanks with a glance at a calendar, instead of racking your brain to find the exact location in your short-term memory where that information is stored (something even neuroscientists haven't figured out how to do). Once you stop using your brain as a filing cabinet for mental notes, you'll free it up to do what it's actually good at: dreaming and finding ways to make those dreams come true.

| tip |

Many little tasks do not always equal one big one.

Sometimes instead of doing the one major, urgent task that could make or break our day, month, or even year—sending out a résumé, for example—we'll do one hundred little tasks that could wait until later. That's when clipping coupons or rearranging the closet stops being productive and starts looking suspiciously like procrastination. Delegate those little tasks, or do them later. Right now, you're on to something big.

| tip |

Say it out loud.

Psychologists have found that writing down your intentions and stating them out loud are both effective means of "rehearsing," or prompting the brain to remember a planned action. So to give your memory a boost, say out loud "Michael . . . lunch . . . noon . . . Tuesday" as you write down that date. Sounds crazy, but it really works!

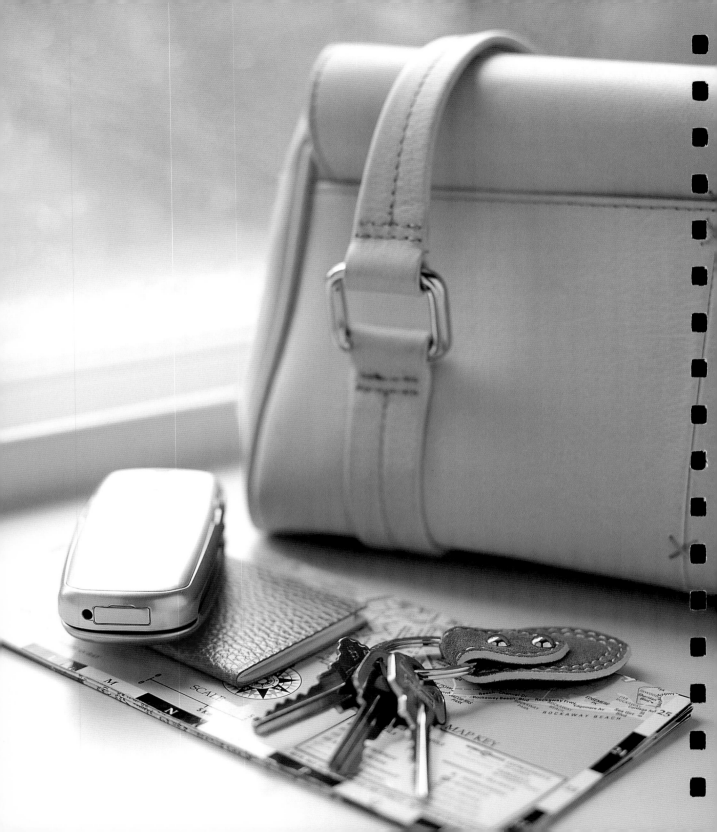

Make it a date. Write down all appointments—even a standing one for lunch with friends. You need to note everything so that when you glance at a specific week or day, you'll know exactly what it holds for you. If you make a tentative plan or tell someone you'll contact them at a specific time, make a date on your calendar.

Note it *now*. Psychologists say that although our short-term memory is only able to store information for about one minute, we can greatly increase our chances of remembering by capturing that thought while it's still fresh in the mind. A minute is not a lot of time, so keep your date book, digital voice recorder, or electronic organizer handy!

Break it into bite-size chunks. There was a time when psychologists agreed that the average human brain could remember no more than seven items at once; now they believe it's more like three. So instead of counting on your memory to digest a long to-do list that's the mental equivalent of a seven-course meal, try grouping things together into "chunks" your mind can actually handle. Here's how that works:

Detailed List

- Call Jeffrey about tennis.
- Call plumber about garbage disposal.
- Get card for Marilyn's birthday.
- Find present for Marilyn's birthday.
- Get wrapping paper for present.
- Mail present.
- Check in Friday with Roni about book club on Sunday.
- Reschedule date with Stephen from this Saturday to next.
- E-mail Elyse about dinner Saturday.

Chunked List

- Phone calls: Jeffrey, plumber
- Marilyn's birthday: card, gift, wrap, mailing
- Weekend plans: Roni, Stephen, Elyse

Go public. Write it on your to-do list; write it on the family wall calendar; leave yourself a voice-mail reminder; announce your intentions to friends and family. Then, if you get waylaid or start to procrastinate, you're bound to be reminded of your original intention. You'll see it on your list and the calendar, you'll hear it on voice mail, and other people will ask you about it.

Always leave the house with a clear sense of direction. You're rushing to get out of the house, into the car, and out of the driveway when it suddenly dawns on you: you have no idea where you're headed. When recording an appointment, write down the address, telephone number, and directions in the accompanying space, so you won't waste time and gas money driving around in circles. Be sure to review this information before you leave the house, and take it with you.

Review your activities at least one week in advance, so you'll know what is scheduled and be able to make changes if you need to. This includes checking the family wall calendar daily to see if there is information that you need to add to your personal calendar. You don't want to schedule a meeting for the same time you promised to pick up your kid at football practice!

Problem:

I trusted someone else to do it, and then it didn't get done.

Some of us make the mistake of thinking that as soon as we've delegated a task, it should disappear entirely from our to-do lists. Not so. Counting on others to do tasks is entirely reasonable; counting on them to *remember* to do them is another story. Let's be honest here: do you remember everything everyone tells you?

Delegating needs to be more than a passing idea communicated to the other person when it happens to occur to you. Friday night at a bar probably isn't the best time and place to hit up a friend to take care of your cat while you're out of town for the weekend—starting tomorrow morning. What if he's too busy flirting with the bartender to remember that he's going out of town, too, or discovers he's lost your keys? That'll be one sorry cat! See page 146 for tips on choosing the right time and place for delegating.

Once you've described the task and provided all the instructions and necessary supplies, you've gotten through *half* the work of delegating. Next, you need to schedule a time to follow up on the task, preferably long enough before you need the task completed that it could still get done, start to finish, in the remaining time. When the task is finally done, you need to show some gratitude for the help you were given. Check out the next page for details on follow-ups and appreciation.

Why go through the trouble? Successful delegation does two things: it saves you time and stress, and it secures you more help in future. If you give someone a task that is manageable, took no longer than you claimed it would, and wins praise upon completion, then that person is going to be that much more game to help you out in the future. Sure, delegating well takes a little longer than just barking orders—but if it means you can get cheerful help on future projects, it's worth it.

The Personal Organizing Workbook

Go ahead and ask for favors—as long as you follow up.

If you have to wriggle out of a volunteer commitment and find someone to take your place, be sure that you provide information and support for a smooth transition. You don't want that person to feel you're passing the buck, or offloading an impossible task. Think about it: When a task is dumped in your lap without any support from the person whose responsibility it was to begin with, do you give it your all? Or do you resent the task and the person who gave it to you, drag your feet until the last possible minute, and leave it dangling half-done at the bottom of your list of priorities? Enough said. And remember: saying thanks stores up goodwill for future favors.

Organizing Solutions:

May I have your attention, please? There is a time and a place for delegation: well in advance of when the task needs to be done and anywhere but in front of the television, computer, or some other distraction. This means not asking your son to wash the car when he's playing video games—wait to describe the task at hand until *pause* is pressed and he has a pen and paper. He'll appreciate having the latitude to finish the game, too, instead of being required to hop to it.

Set up your helper for success. You'll want to make sure the task is clearly understood, and that the person taking it on is set up to succeed at it. Walk your friend through the task, and be sure to provide:

- *Supplies:* Does the friend who's feeding your goldfish have your house keys and know where to find the fish food?

- *Instructions:* Does your friend understand how to work that tricky lock on the door? How much food does the fish get? What about cleaning the tank? Write this information down.

- *A task time frame:* Let your friend know how much time to allow for the task, bearing in mind that it will probably take a newbie longer to do it than it does for you, since you do it every day. If it takes you ten minutes, you might want to tell her to allow twenty. Then she'll feel like a champ for being efficient enough to get it done in fifteen.

Follow up. Schedule a follow-up time in your calendar, next to the person's name, phone number, and a keyword describing the task. Check in once or twice after you've made your request, and do it in plenty of time to make sure that the task gets done and you can provide further direction as needed. That way, if your less-than-organized teenager "completely spaces" on cleaning up the mess in the living room before company arrives, you're not stuck rushing to try to do the job yourself—or worse, blowing up at your teen while the pot roast is blowing up in the oven.

Have a little faith. If you delegate a task, it's not your job to hover over someone's shoulder as he or she does it; that's micromanaging. If do you feel the need to micromanage, that might signal some misgivings about the reliability of the person you've delegated to—something to keep in mind for next time, maybe, but for now, you have to make the best of it and show some faith that this person can get the job done.

Be grateful. Look at it this way—any job you didn't have to do is a job well done. So what if the job isn't done exactly how you would have done it? You might want to give a more tangible token of your appreciation for bigger tasks or frequent favors: pizza for friends who help you move, gas for that colleague who always drives you home from work, some home-baked cookies for the teacher who's gone that extra mile to help your son with math.

Are we having fun yet?

Sounds like someone needs a break from the social treadmill. Give yourself permission to cancel a few engagements this week, and take that time to really reflect on what makes you happy. Make sure your priorities are straight and that your time commitments match your goals and priorities. Honor yourself and your life priorities for a change; before you can share the best you have to offer with others, you need to find it within yourself.

Once you know how wonderful those few stolen moments can be, you'll want more—so schedule nothing for next week. That's right, nothing! We schedule constantly: visits with friends, dental appointments, haircuts. Believe it or not, unless you schedule nothing, you'll never find time for it.

There is a point to doing nothing, and here it is: you have to have fun to stay organized. Organization takes effort, and sometimes when you're feeling tired or just not up to it, you need that incentive of fun just ahead to pick your clothes off the floor or plan out the meals for the week. You can't trick yourself either; once you've promised yourself a good time, you have to deliver. Otherwise, you won't believe yourself next time—and those clothes will stay right where they fall, and you'll open the fridge on Wednesday and find there's nothing to eat. Change a vicious cycle into a winning one: good organization allows you to have a good time, and having a good time allows you to be organized. What's not to like?

tip

Embrace an empty schedule.

"Work hard, play hard" is overrated. Your social butterfly wings will be seriously dragging if you commit to so many events that you spend half your weekend coordinating with friends; picking up tickets; buying flowers, wine, and presents; changing clothes; and driving from one event to the next. (Whew . . . that list is exhausting!) So if Friday evening rolls around and you have no plans, luxuriate in that time. Take a sunset stroll or a long bath, catch up on some pleasure reading, write a card to an old friend, or impress yourself by cooking up a fancy new dish from a magazine. See what great company you are?

Organizing Solutions:

Take a breather. Are you getting at least twenty minutes a day to yourself, with no interruptions? It's hard to interact with others when you've lost track of who you are. Try these tricks to make sure you get some quality alone time:

Consolidate and eliminate tasks to buy yourself those precious few minutes.

Make like a Zen monk, and combine meditative time with a mindless but not unpleasant task, like folding laundry, raking leaves, or gardening.

Steal an hour from your social calendar. When a friend calls to invite you somewhere, consider how long it's been since you've had an hour to yourself. If it's been awhile, suggest a later date, and keep that time for yourself.

Trust your instincts. Consider any misgivings you may have before making a time commitment, no matter how small. You wouldn't waste your money, so why waste your time? If your friend has invited several people hiking and you don't know many of them, and hiking isn't really your thing anyway, do yourself and everyone else a favor and say no! If it doesn't sound like fun to you, it probably won't be—and you don't want to spoil it for everyone else.

Calculate the actual time commitment. Going to the movies on Friday with a friend who lives the next town over may sound like a great idea. But before you say, "Sure, why not?" factor in the actual time involved, not just the two hours you'll be sitting in the movie theater. If the movie starts at 6:00, does that mean you have to leave work at 4:30 just to avoid rush hour traffic? Is your friend going to want to grab a bite afterward, or need a ride home? How long is it going to take you to get back?

Give yourself an out clause. Instead of blocking off the whole day for a block party that may or may not be fun, plan to go for just an hour, and then do something that you know will interest you afterward. If the block party is a total blast, you can always push back your plans a bit.

tip

Turn onerous obligations into fun with a friend.

The thought might have crossed your mind to hire an incredibly versatile actor to pose as you at boring charity committee meetings, and onerous family obligations—but that might raise suspicions. Instead, ask a friend to do you a big favor and come along, with promises of an early exit and much adventure. Maybe the two of you can have lunch together after that fund-raising committee meeting, or plan a getaway from Grandma Mary's brunch before she starts trying to fix you up with the neighbor again.

Seize the Day!

Time required: 20 minutes

That's right: Twenty minutes a day is all it takes to get the most out of those other twenty-three hours and forty minutes. Tasks will get done that much faster, so you can get on with the fun stuff. Best of all, you'll finally get around to some of those big ideas and lifelong dreams that have been put off far too long already.

In the Morning (10 Minutes):

1 **Take a minute to collect your thoughts,** and look over your to-do list. Check and make sure you've got your priorities straight, and see which tasks can be grouped together:

- Similar tasks, such as phone calls or paperwork

- Tasks in the same area, such as errands on the west side of town or kitchen chores

- Tasks that fit a particular time slot, such as things that you need to do before work or after you pick up the kids from school

2 **Think about one thing you'd really like to do today.** Maybe it's the perfect sunny day for a walk in the park, or there's a friend you'd like to catch up with over lunch. Or maybe you could do both, and have a picnic . . . now you're thinking! Write it on your to-do list—at the top.

3 **Schedule the time you need to make your wish for the day come true.** Schedule a time this morning to call your friend, and see if you can build in an extra ten minutes at lunch so you can enjoy a leisurely stroll and maybe an ice cream.

4 **Note any flashes of inspiration.** If a bright idea for a business venture selling the lavender that's taking over your garden occurs to you out of the blue on your walk, or your friend recommends a great book she's just read, take a minute before you go back to work or resume your day to jot it down on the bottom of your to-do list or calendar, or whip out your voice recorder and make a note of it.

In the Evening (10 Minutes):

1 **Look at today's to-do list,** and note with satisfaction all the things you've crossed off today. Check you out!

2 **Glance over your schedule for tomorrow,** and see what needs doing. Jot these down on a fresh to-do list, in rough order of priority. You may be tired at the end of the day, but that's what makes it a good time to do tomorrow's to-do list—you'll be more relaxed and realistic now than you would be in the morning. Don't worry about the exact order now; you'll settle that tomorrow morning.

3 **Take a long, hard look at the tasks you didn't get to today,** and consider if you really need to do them tomorrow. Do you need to call the plumber yourself, or can you delegate it to your mate instead? Do you really need to get those shoes you wanted to wear at the gala on Friday, or will the ones in your closet do just fine?

4 **Review the notes** you jotted down or recorded today, and think about how you could act on these inspirations. Remember that business venture idea? Schedule some time next week to do some Web research, or download some sample business plans. How about that book your friend raved about? Maybe you'll want to add that to your master list of things to get for your upcoming beach vacation, or see if you can score a signed copy of the author's brand-new book for your friend's birthday.

Plan a Winning Week

Time required: 1 hour

Now that you've seen what you can accomplish in a single day, imagine what you can do in a well-planned week . . . better yet, give it a whirl! Planning this far ahead gives you more room to delegate, and schedule activities for times that work best for you.

Set Up a Daily Routine (30 Minutes)

1 **Figure out what always needs doing on a daily basis:** getting dressed, packing the kids' lunches, bringing in the mail and paper. Once you've got it, jot it down.

2 **Work out who needs to do what.** Now notice I say here not who **does** what, but who **needs to do** what. Do you personally need to walk the dog, or could your roommate do it? If she can't, what about a professional dog walker? You may dress your kids, but do you really need to—especially if it's making you late for work?

3 **Delegate.** You might put household responsibilities in a chore chart in a high-traffic, high-visibility spot, like the front of the fridge. That way, no one will be left guessing who's responsible for what. Delegating may seem like a drag, but giving people responsibility and trust actually does wonders for their self-esteem and cements your relationship. There could be unexpected positive side effects, too: your roommate might come to love your dog, too, and picking out their own clothes might inspire your kids to develop their creativity and individuality.

4 **Find the right time slot.** If the mail arrives in the morning as you're rushing off to work, that might not be the best time to sort through it. On the other hand, going through the mail during the commercials while you're watching TV in the evenings might be just the ticket. Look for the best spot in your schedule.

5 **Go with the flow.** If sitting down to breakfast gets your day started right, plan your other morning activities around that. Get dressed and ready so that you can enjoy a leisurely coffee without fretting that you still have ten more things to do before you leave the house.

6 **Insert a pause.** Make sure you have a moment in the busiest parts of your daily routine to come up for air, and collect your thoughts. This will do wonders for your attitude and your efficiency, too.

7 **Road-test it.** At the end of the day, see if you're still in the flow, and take note of how much you accomplished. Were there any rough patches that needed smoothing over? You don't have to follow your routine religiously; if it doesn't serve you, switch it up until it does.

Set Up a Weekly Routine (30 Minutes)

Repeat the above, this time with weekly chores in mind: accounting, housecleaning, bulk grocery shopping, recycling and garbage, phone calls to make arrangements for next week's appointments, etc.

Put Your Dream into Action

Time required: 1 hour . . . and then the rest of your life

If a genie suddenly flew out of this book and granted you one wish, what would it be? Many people would wish for time—they'd want to live forever, or enjoy more time with their family, or have twenty-five hours in a day. But now that you've gotten organized, you don't need a genie to grant you more time. Since you use your time wisely, you've got all the time you need to live your dreams. So what's that wish going to be? Here's where you find out, and start to make it happen.

1 **Dream a little dream.** You remember how to daydream, right? As kids
 in school, we were all pros—so take a minute wherever you are and
 channel your younger self. Rest your head in your hands, stare out the
 window, enjoy the sun on your face or the rain coming down, and let
 your mind wander. What thoughts drift into your mind that have been
 lurking there for who knows how long, waiting for the opportunity to
 make themselves known? Are you thinking of swaying palms and sandy
 beaches or race-car tracks and the roar of a crowd? Are you lying on
 the beach or sitting in the driver's seat?

2 **Think small.** Backtrack *slooowly* from your dream to reality. Just before
 you reenter life as you know it, what's the last step that comes to mind?
 Would it be a plane ticket or a Formula One driving-school certificate?
 Now you've got it—your immediate goal is to achieve this first, tangible
 step toward your goal.

3 **Consult your schedule.** When is the soonest you can possibly fit in
 some time to do a bit of research toward your immediate goal? Could
 you go to the library tomorrow to borrow tropical travel guides? Can
 you hop on the Web today to find racetracks that offer classes near you?

4 **Take baby steps.** Once you've figured out what you need to do to get to your immediate goal—set aside *X* amount for plane fare to Bora Bora or save up vacation time to take lessons at the racetrack in Indianapolis—schedule time as often as possible to make progress in that direction. Make it a priority, and make it daily if possible.

5 **Call in reinforcements.** Next time you catch yourself saying, "I can't do this," remember this: you don't have to go it alone. When in doubt, don't hesitate to call for backup from a friend or professional organizer who can help you with

> • *Accountability.* You'll make an added effort knowing someone is watching over you and cheering you on. Ask your friend or coach to call and check on your progress by asking you these four questions:
>
> > *1.* What have you already (hooray!) managed to get done today?
> > *2.* What's one other thing at the very top of your priority list that you'd like to get done today?
> > *3.* What would it take to make that one thing happen?
> > *4.* If finishing that one thing today isn't feasible, can you break off a chunk of it to do now and set a date to finish the rest later?
>
> • *Aid.* Some things other people just can't do for you, and living your dream is one such thing. What others *can* do for you is give you time to vent and help you come up with a plan of action to tackle any obstacles you encounter along the way.
>
> • *Advice.* Even if you don't end up taking the advice, seeing your situation from a fresh perspective may be all the help you need to get unstuck, and start making serious strides.

6 **Arrive, and achieve.** This is your reward for organization: living your dreams. Congratulations—and keep up the good work!

tip

Note bright ideas.

Keeping a journal is a great way to make sure that no inspiration is ever lost.

RESOURCES

RESOURCES

BOOKS

Family Time

52 Special Traditions for Family and Friends
by Lynn Gordon

A full deck of ideas for reconnecting and cele-brating with loved ones.

A Gracious Welcome: Etiquette and Ideas for Entertaining Houseguests
by Amy Nebens

Friends coming over, or family in town? Take these tips for a relaxing, enjoyable visit—for you and your guests.

The Working Parents Cookbook
by Jeff and Jodie Morgan

Turn dinnertime into quality time with more than 200 easy, healthful, kid-friendly recipes for great family meals.

• • •

Friendly Get-Togethers

At Home with Friends: Spontaneous Celebrations for Any Occasion
by Michele Adams and Gia Russo

Good food with good friends made easy with menus, planning tips, and checklists for brunches, cocktails, buffets, and dinner parties.

Dinner Parties: Simple Recipes for Easy Entertaining
by Jessica Strand

Delight your guests with simple, sensational dishes, whether you're planning an intimate dinner for four or a lavish feast for twelve.

Pad Parties: The Guide to Ultra-Entertaining
by Matt Maranian

Oh no, not another luau! When you feel like you've been there, done that with all the usual theme party ideas, take these tips to surprise your guests and yourself with your hipness and creativity.

• • •

MAGAZINES

Home Organization

The Home Organizing Workbook: Clearing Your Clutter, Step by Step
by Meryl Starr

Clear the clutter and make room for living in your home, one room at a time.

The Feng Shui Deck: 50 Ways to Create a Healthy and Harmonious Home
by Olivia H. Miller and Sheryll Hirschberger

Insights and ideas to create a harmonious, productive atmosphere in your home.

• • •

Putting Dreams into Action

You Can Do It! The Merit Badge Handbook for Grown-Up Girls
by Lauren Catuzzi Grandcolas

Start living your dreams with this book of daring activities you've probably dreamed about, but haven't gotten around to trying . . . until now!

Parenting
www.parenting.com

Learn on the job with this indispensable resource for managing your tasks and time as a parent.

Real Simple
www.realsimple.com

Easy-to-follow tips for handling everything from maintenance to mutual funds, so you can enjoy life more with less hassle.

TOOLS

Date Books and Electronic Organizers

At a Glance
888-302-4155
www.ataglance.com

Daily, weekly, monthly, and annual planners and calendars

Blackberry
www.blackberry.com

Electronic organizers with cell phone and e-mail capabilities

Filofax
www.filofax.com

Date books and daily planners

Palm Pilot
www.store.palmone.com

Electronic organizers with downloadable address book and optional e-mail capability

Polestar Calendars (Canada)
www.polestar-calendars.com

Date books and calendars for the whole family

The Organiser Shop (Australia)
(03) 9639 3633

Date books, calendars, journals, and more

Storage

The Container Store
www.containerstore.com

Storage containers and systems

Exposures
800-222-4947
www.exposuresonline.com

Photo storage and archival boxes

Hold Everything
800-421-2264
www.holdeverything.com

Storage products

Rubbermaid
888-895-2110
www.rubbermaid.com

Home organization and storage

Tupperware
800-366-3800
www.tupperware.com

Storage for home and car

Home Organization Supplies and Systems

Bed Bath & Beyond
866-891-5294
www.bedbathandbeyond.com
Home and storage organization

Bed Bath 'n' Table (Australia)
(03) 9387 3322
Home and storage organization

Binz—The Container Store (Canada)
416-690-4611
Storage solutions

California Closets
800-274-6754
www.calclosets.com
Closet organization/design

Easy Closets
800-910-0129
www.easyclosets.com
Customized closet systems

Hammacher Schlemmer
800-321-1484
www.hammacher.com
Home organization systems

Ikea
www.ikea.com
Shelving systems, containers, closet units, and desk organization

OfficeMax
800-788-8080
www.officemax.com
Supplies for organizing and filing paperwork

Staples
800-333-3330
www.staples.com
Folders, envelopes, calendars, and filing systems for paperwork

Storage King (Australia)
(03) 9427 1444
www.storageking.com.au
Home organization and storage systems

• • •

WEB SITES

Charitable Organizations

www.auscharity.org

Your extra stuff could do a world of good for these Australian charitable organizations.

www.canadian-charities.com

Give Canadian charities a boost with your donations of items in good condition.

www.charitynavigator.org

Find worthy U.S. charities that could put your extra career clothes and household items to good use.

www.princessproject.org

The Princess Project, a U.S. nonprofit, distributes donated gowns to needy teens for school dances and other special events. Find similar organizations near you, or start your own chapter!

• • •

Controlling Junk Mail

www.dmaconsumers.org/consumerassistance.html

Get yourself removed from mailing lists using the Direct Marketing Association (DMA)'s Mail Preference Service.

www.privacyrights.org

Organizations selling your name and address? Know your rights.

www.junkbusters.com

Follow these tips to minimize unwanted mail.

• • •

Stopping Telemarketers

888-382-1222
www.donotcall.gov

Add your phone number to the U.S. National Do Not Call Registry.

Easy Entertaining

www.allrecipes.com

Access thousands of recipes, plus newsletters, nutrition planners, and an online recipe box.

www.epicurious.com

Download recipes for your entire menu, from cocktails and canapés to memorable holiday feasts, including recipes from Bon Appétit, Gourmet, *and* Parade *magazines.*

www.evite.com

Send invites and automatic reminders online.

www.netgrocer.com

Let the groceries come to you, with home delivery of nonperishable grocery, drugstore, and general merchandise across the United States.

www.wineloverspage.com

Become your own expert sommelier with this source of wine information, vintage charts, prices, glossary, lists of favorites, and user forums.

www.wine-searcher.com

For wine and cheese night, use this searchable database of wine prices and retailers to locate the wine you want at a store near you.

- - -

Professional Organizing Advice

www.merylstarr.com

Learn more about Meryl Starr and the importance of organization and decluttering your life.

www.interiordec.about.com/cs/homeorgarticles

About.com's guide to organizing offers links to recommended articles.

www.napo.net

The Web site for the National Association of Professional Organizers (NAPO); get a referral to a professional organizer, or locate a chapter near you.

The photographer would like to thank the following companies for their generous assistance.

The Container Store

www.thecontainerstore.com

Doe

629A Haight Street
San Francisco, CA 94117
415.558.8588
www.doe-sf.com

Filofax

www.filofaxusa.com

Hable Construction

www.hableconstruction.com

Hello Lucky Letterpress

415.355.0008
www.hellolucky.com

Jonathan Adler San Francisco

2133 Filmore Street
San Francisco, CA 94115
415.563.9500
www.jonathanadler.com

Kate Spade

www.katespade.com

Otsu

3253 16th Street
San Francisco, CA 94103
415.255.7900
www.veganmart.com

INDEX

A

ATM receipts, 34

B

Bills, 51
Boundaries, setting, 105
Bulletin boards, 31

C

Calendars
for family events, 64, 81
types of, 64, 74–75
using, 64, 75–76, 78–79, 81, 143
Cars, 42–43
CDs
in the car, 42
collections of, 39
Cell phones, 34
Change, 35
Checkbooks, 35
Check cards, 35
Children
backup arrangements for, 90
organizing and, 31
preparing, for school, 90
traveling with, 43
Chore board, 73
Closets
for gifts, 137–39
lack of space in, 38–40
organizing, 45–47

Clothing
organizing, 45–47
receipts for, 50
Clutter. *See also* **Possessions**
reasons for, 26, 28
reducing, 24–26, 28–29, 31
Collections, 39
Cosmetics, 34
Credit cards, 35

D

Delegating, 73, 123–24, 144–46, 152
Documents. *See* Papers
Doll collections, 39
Drawers
junk, 29
lack of space in, 39–40
Dreams, 64, 154–55

E

Entertaining, tips for, 122–24
Errands, 72, 73

F

Family. *See* Children; Relationships
File cabinets, 31
Finishing, importance of, 51
Focus, maintaining, 72–73

Friends. *See also* **Relationships**
entertaining, 122–24
making time for, 108, 112
seeking help from, 73, 146, 149
Fun, importance of, 147, 149
Furniture, arranging, 26

G

Garage sales, 40, 47
Gift certificates, 35
Gifts
receipts for, 50
regift closet for, 137–39
Glove compartments, 42
Goals, setting reasonable, 68–69
Greeting cards, 81
Grocery shopping, 72
Gym membership cards, 35

H

Habits
changing old, 135, 136, 137–39
organization as, 11
Help, seeking, 73, 123–24
Holiday plans, 120–21

I

Inspiration, sources of, 26

The Personal Organizing Workbook

INDEX

INDEX

Author's Acknowledgments

To all of you who purchased and benefited from *The Home Organizing Workbook: Clearing Your Clutter, Step by Step,* thank you and congratulations, my best to you always.

To all of the wonderful and talented people at Chronicle Books: thanks for your support and creativity. Mark Bailin, my attorney and chief negotiator, many thanks. Lisa Campbell, my editor . . . thanks for stepping up to the plate, being there, and making sure this book was exactly what it should be. Thanks to Leslie Davisson for your continued support and friendship. A special thanks to Alison Bing for taking my words, thoughts, and ideas and making them sing. . . . I loved working with you.

To my best girlfriends Elyse Furlong, Roni Doppelt, Marissa Wolf, Teri Marks, Linda Roberts, Fran Drescher, and Amy Olsen: thanks for being my eyes, for giving me strength, and for opening up your hearts.

To Alyson and Andrew: you are my joy, my laughter, and my sunshine. Thank you for all you add to my life.

— **Meryl Starr**

AUTHOR BIOGRAPHY

Meryl Starr is the author of the best-selling *Home Organizing Workbook* (Chronicle Books) and is an internationally known organization expert. As owner of Let's Get Organized, an organizing service, she's done more than her fair share of tidying up, from humble apartments to the homes of Hollywood celebrities. Meryl teaches her clients to transform their lives with the power and freedom that comes from being organized and in control.

Meryl's tips and ideas for home organizing have appeared in *InStyle, Real Simple, Ladies' Home Journal, House Beautiful, Better Homes and Gardens, Seventeen, Self,* and a host of other magazines and newspapers. She has appeared on *Queer Eye for the Straight Guy* and HGTV's *Smart Solutions,* as well as national and local news programs, and is a featured expert in the book *You Can Do It! The Merit Badge Handbook for Grown-Up Girls.* Based in New York, she also lectures and leads workshops and seminars.